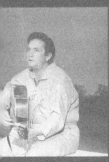
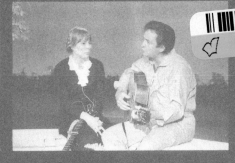

→ 6 →6A →7 →7A →8

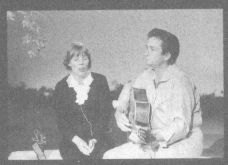
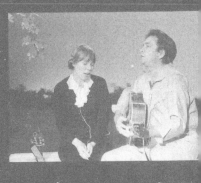

→ 11 →11A →12 →12A →13

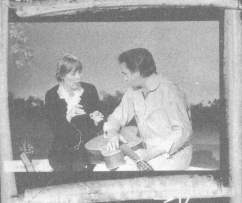

→ 16 →17 →17A →18

Pocket
CASH

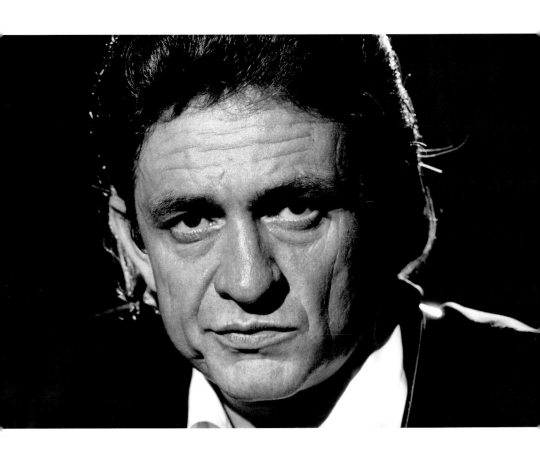

Pocket CASH

by
Jim Marshall

introduction by
John Carter Cash

essay by
Billy Bob Thornton

essay by
Kris Kristofferson

CHRONICLE BOOKS
SAN FRANCISCO

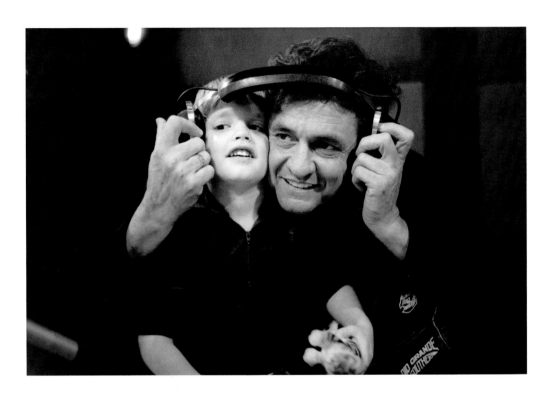

John Carter Cash with his father in their home studio.

WHAT MEETS THE EYE

John Carter Cash

MY FATHER was sometimes uncomfortable in front of a camera. Certainly there were other places he would rather be, but he always did his best to smile in the face of one. There were rarely times when he forgot that the camera was there; that was always up to the photographer.

With many master photographers it's hard to deny their presence. They direct the subject and ask them to stand still for the best shot, to pose. They lead, control, and manipulate the shot—fashion it as they envision it. They add lighting, say "Smile," or ask for specific expressions to make the scene a precise staging—something more created than captured. This is an important art, of course, and is not to be discredited. Some of history's greatest photographs were created this very way. This is the nature of most photography.

There are those photographers who not only capture the essence of the time and space they are photographing but, by some means, also catch the unique power of the precise moment. These photographers, though few, may not be able to say exactly how they do this. Are they merely in the right place at the right time? Are their fingers in some arcane way more in tune with their eyes and minds? They snap the shot they supernaturally know is coming, perfectly in time with the approaching instant. How on earth can they perform such magic? I have never understood.

Then there is the rare photographer who miraculously goes beyond even that. These extraordinary visionaries

not only encapsulate the moment in their images but also create a vision beyond and perhaps greater than the actuality. They do not take from the truth but expound on it, by some means mixing the nuances of chemistry and spirit, of thirty-five millimeter film and blood, calendaring life in a way that is unique to their perspective. In doing so, they give us a glimpse into the very soul of the subject, opening them for our inspection and criticism, allowing us a secret view into their very hearts.

I can read volumes in my father's eyes within the pages of this book, such as on page 33 when he is stepping out of the bus at Folsom Prison before the concert. Is that fear and trepidation in his gaze? Maybe. But there also is, undeniably, courage, wisdom, and purpose in his stare. Could any other photographer who happened to be standing by the bus, perhaps even with a finer camera, have opened a wider window into my father's soul? No one but Jim Marshall. And on page 43, only the back of my father's head is seen, but his spirit is mysteriously within the smile and excitement on Bob Johnston's face. Even if we were in the room at the time, could this be seen in Bob's eyes? Never. Only by Jim.

In this type of photography, the true, magical kind, there is no need for words, staging, or direction. Even the music itself is alive in the pictures. It is all there to be seen, in movement, heart, and definition in those appearing in the images. My mother's character comes back to life when I look at the photograph of her talking to the guard at Folsom (p. 48–49). I imagine she is asking him if it would be possible to have the prisoners brought in a good home-cooked meal. I can see the uneasiness in his eyes with such a question. Is this my imagination? Is it really there? How can such a thing be captured in the millisecond it takes to snap a shot?

I say it is not the machine of metal and glass that is in the hand of the photographer, but the heart of the man himself that makes this possible.

And the images of my father with Waylon Jennings... Of course Jim was photographing two of American music's most famous icons, but to say they are "larger than life" in the photo on page 76 would be an understatement. The photograph itself is alive. More magic.

As I look back through the pages of this book, I see the pages of my father and mother's life, their family, and friends...and also I see mine. The memories come back in a rush. I remember the laughter, the struggle, the friendship, the uneasiness, the triumph, the purpose, the loss, the strength of family, the joy of creation, and the power of love. It is all there. I see the pride in my grandparents' eyes as they watch their son on stage. Again, though my father is not in the picture, I see this as true as if he were. I see the heart's bindings that entangled my mother and father so effortlessly but permanently. I see it in the last pages of this book, as real as if I were once again with them—I can almost hear their breath, feel their tender touch. This is real. This is life.

And as I look through these pages I offer a prayer of thanks. I am grateful that their lives were so purposeful, that it was of such worth and import that Jim could be there to capture it with his magic. This book is so much more to me than merely the images of my parents. It is an indissoluble glimpse back, beyond the reality and into a place that feels even greater and more meaningful than the memories.

So join me on this journey back to the life that was and—thanks to Jim Marshall—the life that remains.

THE PHOTOGRAPHS IN THIS BOOK were made between the mid 1960s and the mid 1970s, an explosive and seminal decade in Cash's long and prolific life. This era contained the worst of his battles with drugs and alcohol, as well the fulfillment of his goal to record a live session at a prison, first at Folsom and then, given the meteoric success of that album, at San Quentin. These years also brought redemption, through an acceptance and treatment for his addictions, a rediscovery of faith, and most important, his marriage to the love of his life, June Carter, and the birth of their only child together and only son, John Carter Cash.

Jim Marshall first met Cash in 1963 in New York, while photographing for Columbia Records, and developed a friendly relationship with him and June. In addition to being requested by Cash to document the Columbia Records sessions at Folsom and San Quentin, Marshall was invited to Thanksgiving at the Cash family home one year, and was given unlimited access (the only way he will work) to the set of *The Johnny Cash Show*.

The photographs in the book are sequenced visually around four major sections—the recording sessions at Folsom and San Quentin, a sixteen-page highlight of rarely seen color photographs by Marshall, and images from the set of *The Johnny Cash Show*.

For additional biographic information, please see the Select Chronology on pages 156–157.

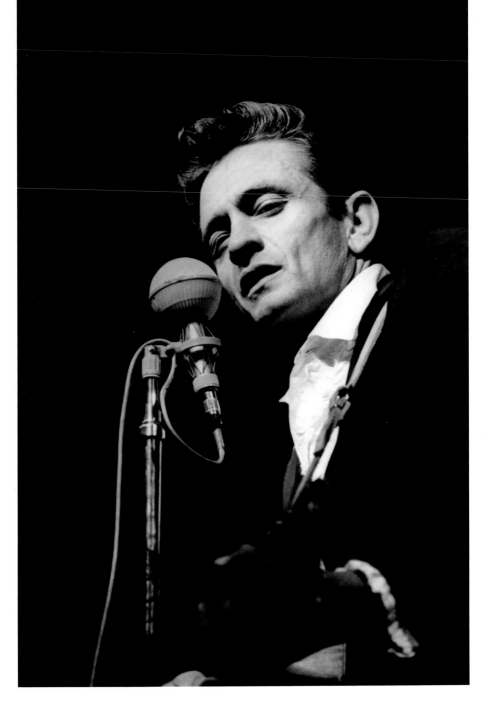

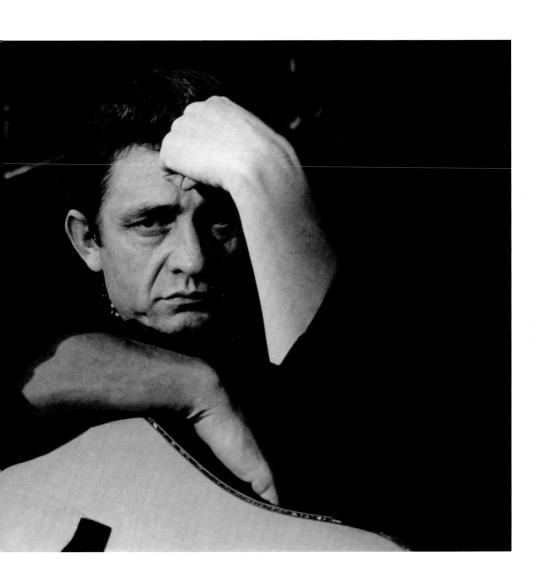

Thanksgiving at the Cash home in Hendersonville, 1969.

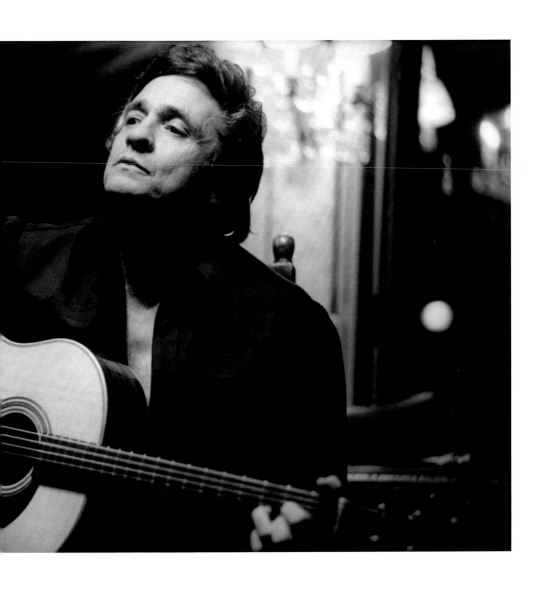

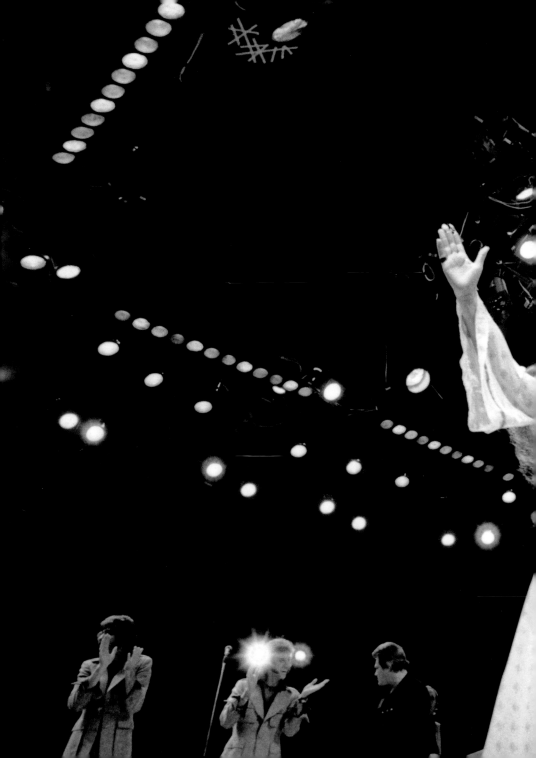

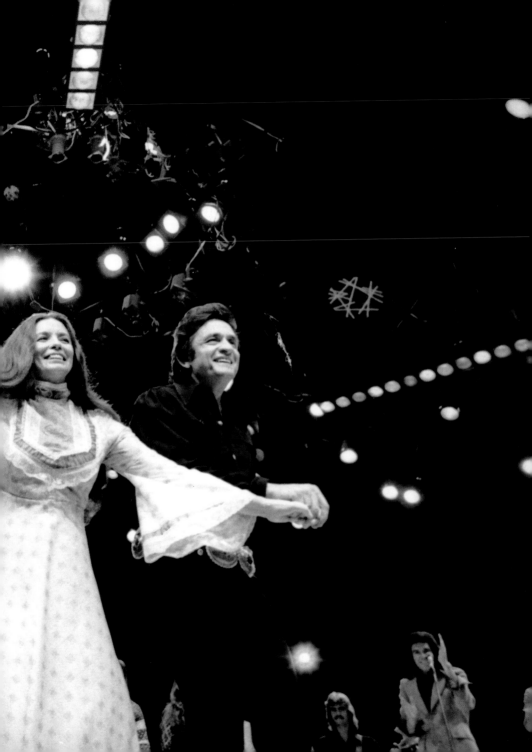

Johnny and June at the Newport Folk Festival, 1969.

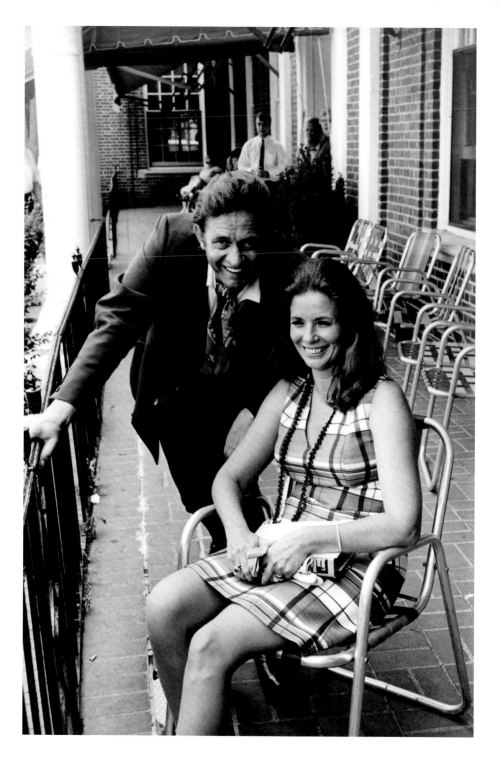

June at the Country Music Association Awards in Nashville.

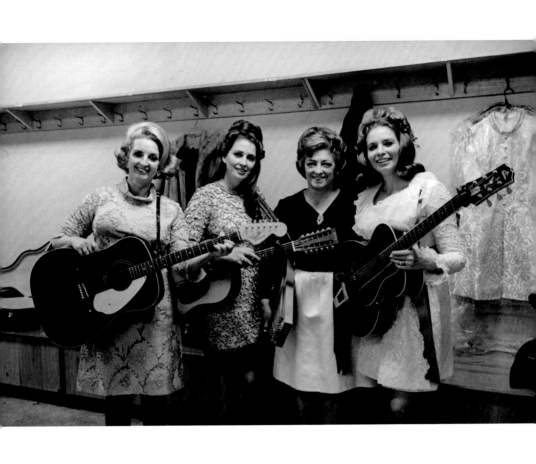

The Carter Family: from left, Helen, Anita, Mother Maybelle, and June, 1969.

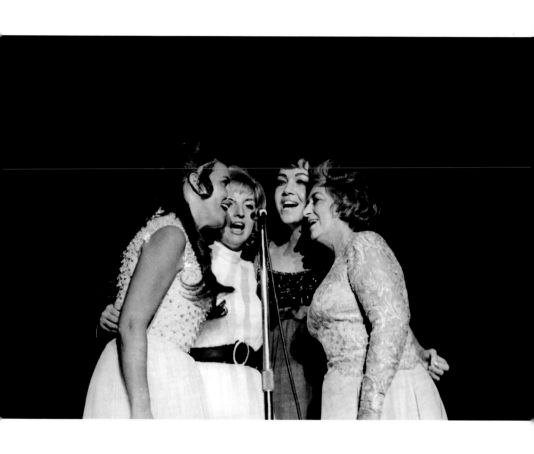

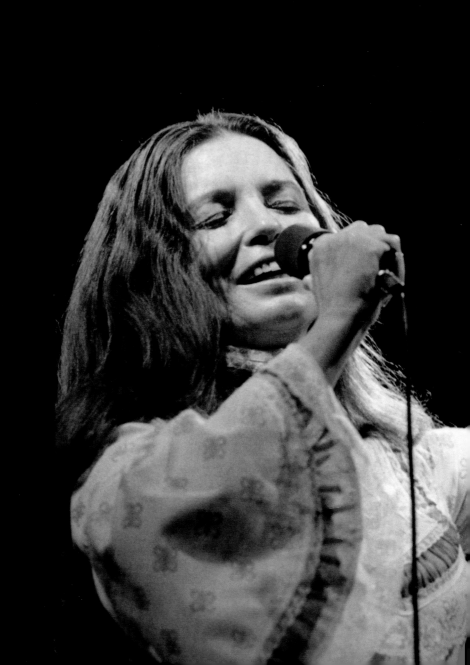

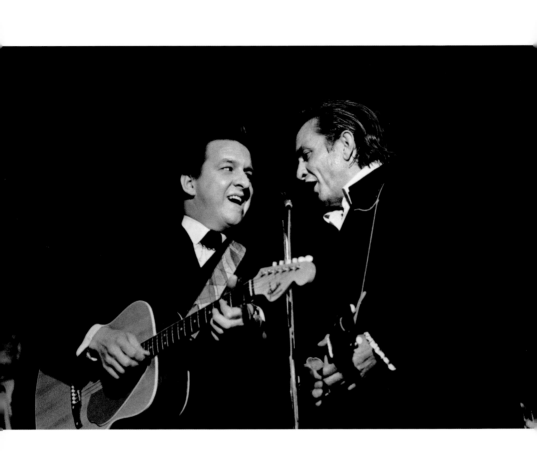

Tommy Cash with his brother Johnny.

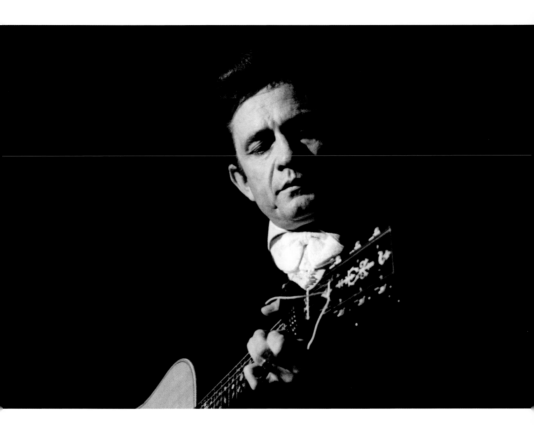

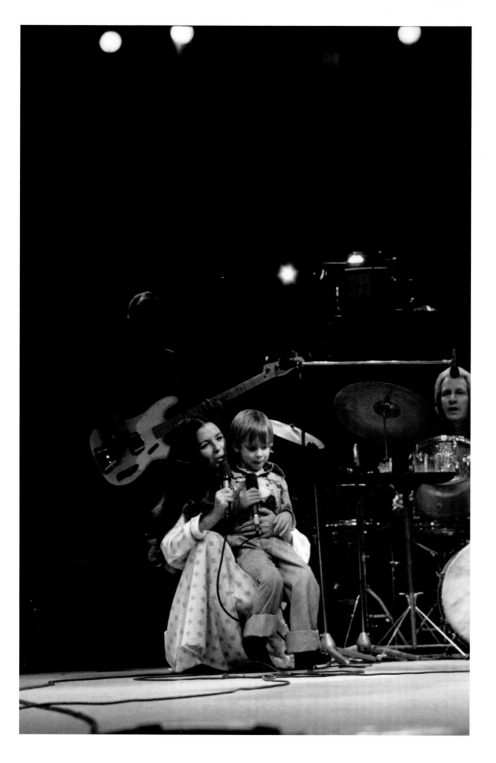

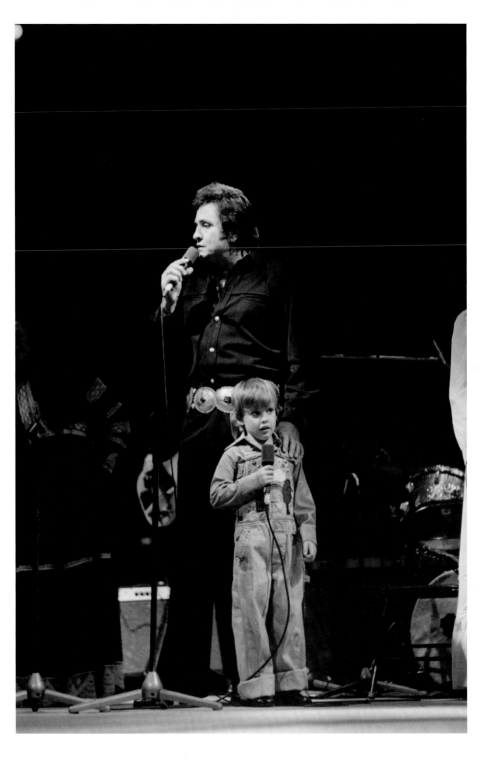

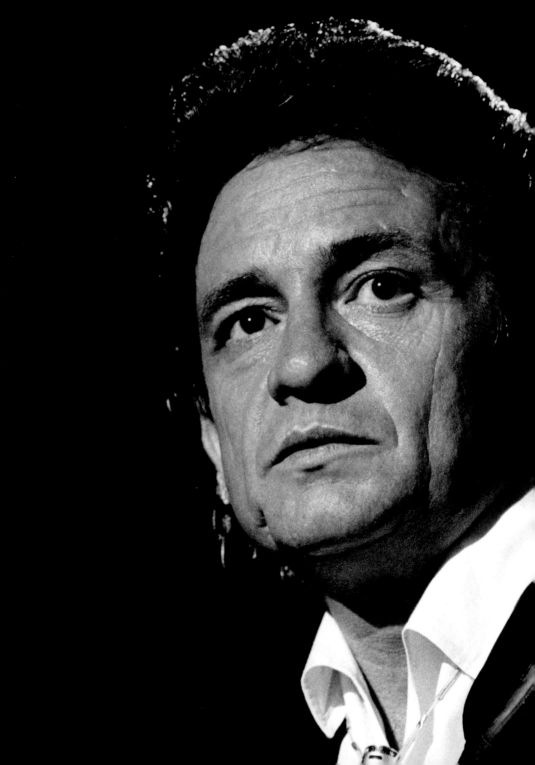

LIVE AT FOLSOM PRISON

January 13, 1968

IN 1953, while stationed in Germany, Johnny Cash first learned of Folsom State Prison through Crane Wilbur's film *Inside the Walls of Folsom Prison*. It inspired him to write "Folsom Prison Blues," first recorded in 1955. Cash and the Tennessee Two performed at a prison for the first time in 1957, in Huntsville, Texas. Eleven years later, Cash was able to fulfill his desire to record a live album at Folsom State Prison in California. His new producer at Columbia, Bob Johnston, who had worked with Simon and Garfunkel and with Bob Dylan, enthusiastically supported Cash in this endeavor. On January 13, 1968, Cash, June Carter, and friends did two shows at the penitentiary that resulted in *At Folsom Prison*. Cash requested that Columbia Records hire Jim Marshall to photograph the sessions, and one of Jim's color photographs, now lost, graces the cover. Within months of the album's release, it was at the top of the country and pop charts, and it has remained one of Cash's best-selling albums.

In addition to performing for prison inmates, Johnny Cash campaigned for prison reform, even testifying before Congress on the subject. Throughout his life, he corresponded with inmates and helped many, including Glen Sherley, whom he met at Folsom after he performed Sherley's song, "Greystone Chapel."

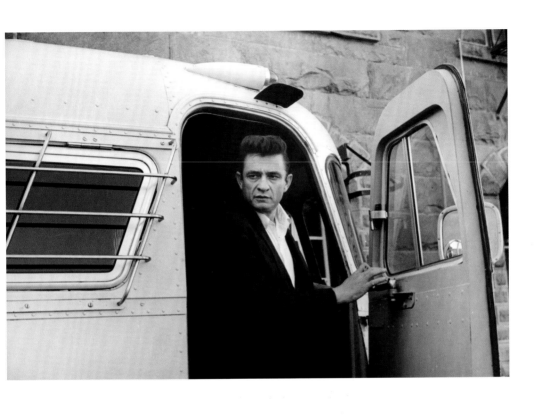

Pages 33–67: Photographs taken at Folsom State Prison, Represa, CA, on January 13, 1968.

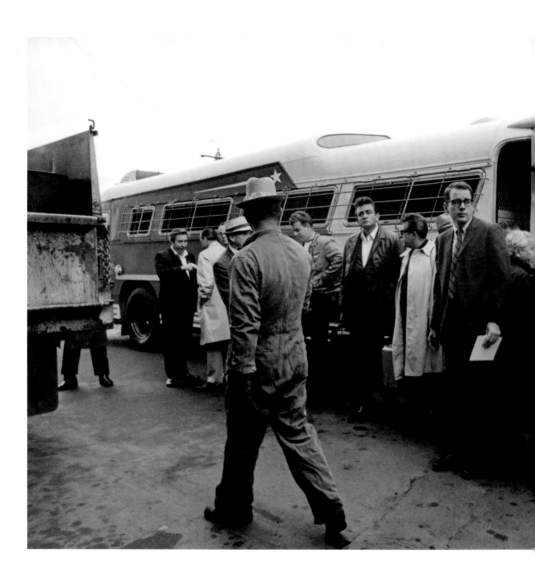

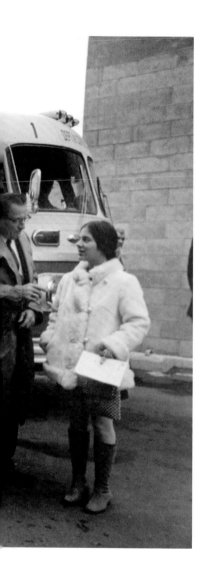

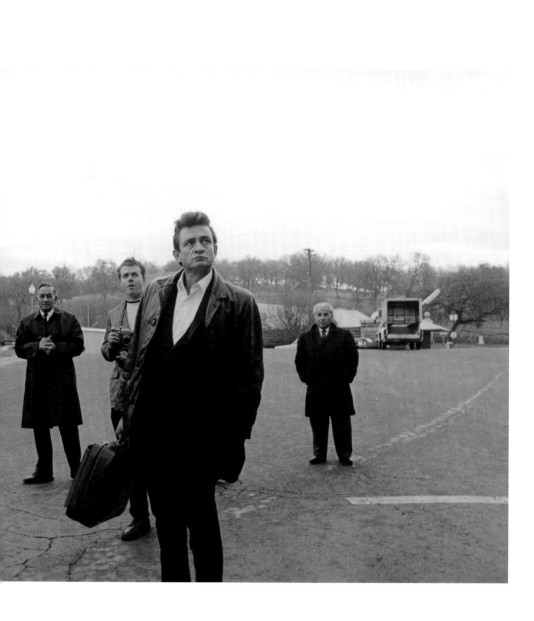

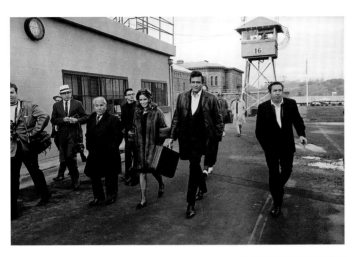

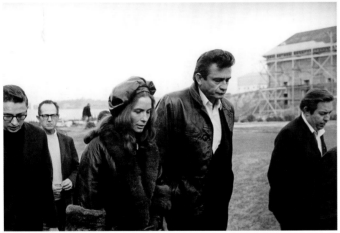

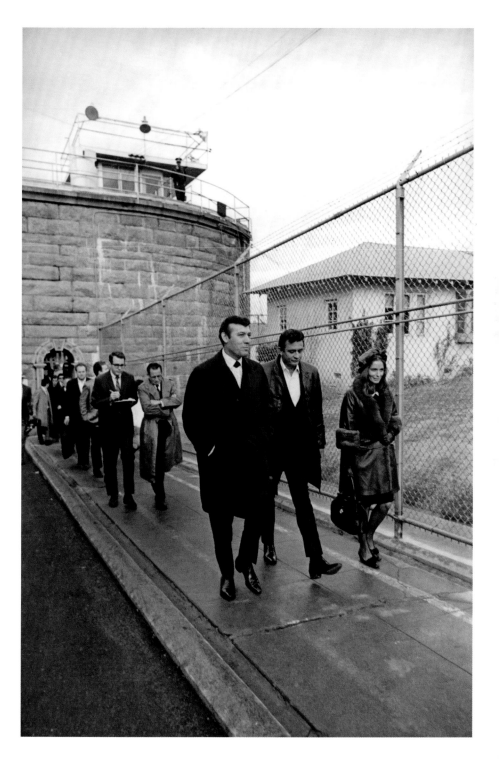

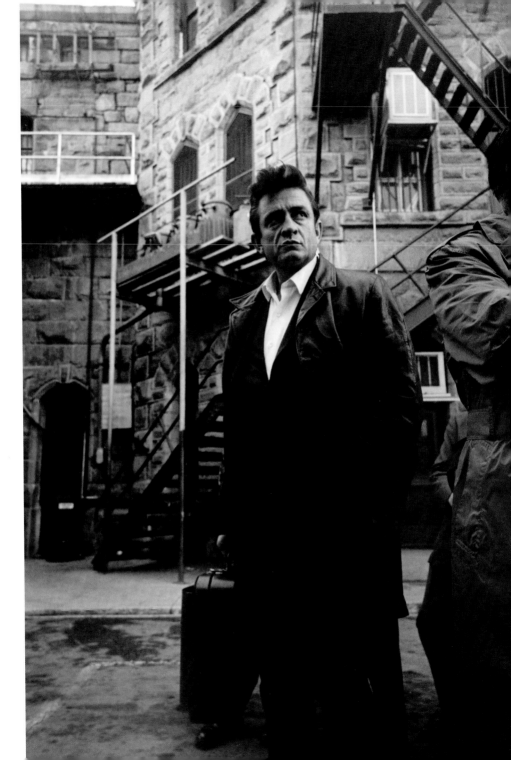

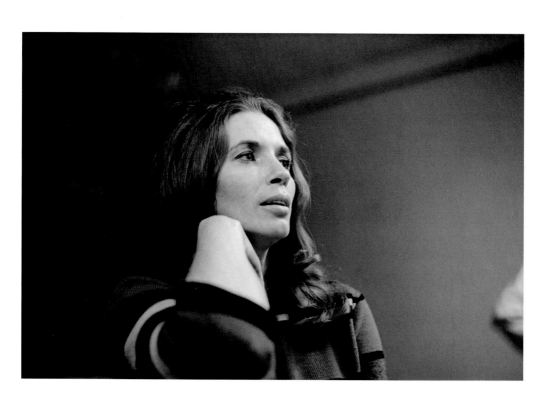

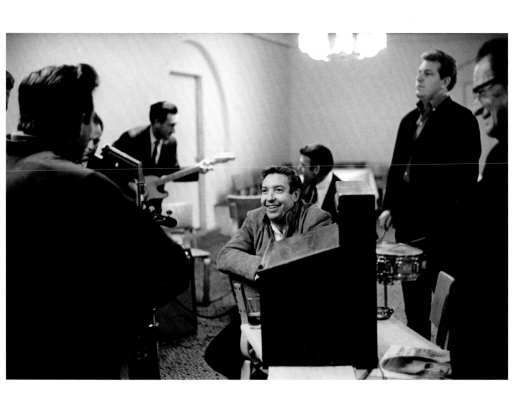

Bob Johnston, Cash's producer at Columbia Records, during rehearsal.

Luther Perkins backstage. Perkins performed with Cash from their beginnings in 1954 until his tragic death in August 1968.

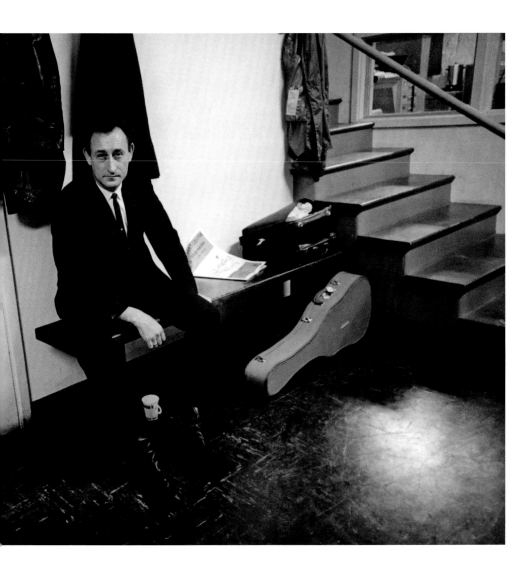

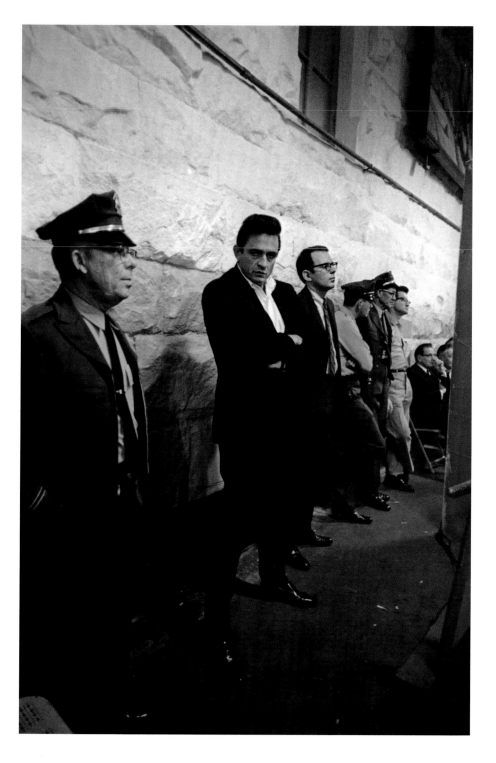

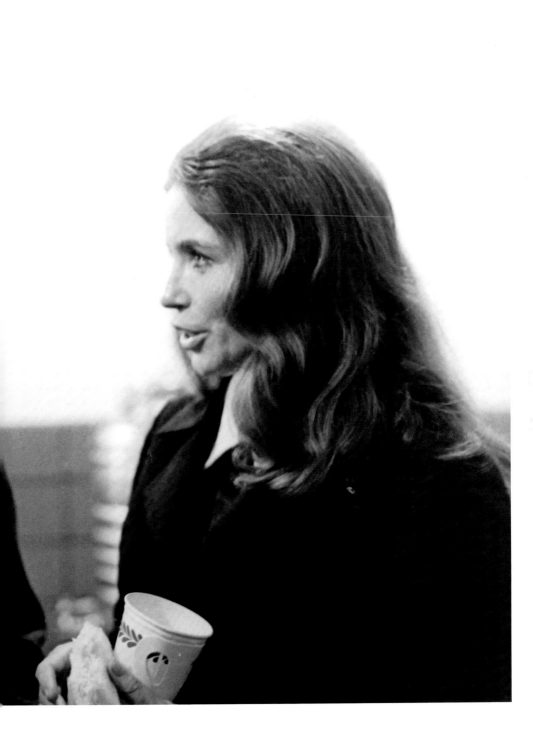

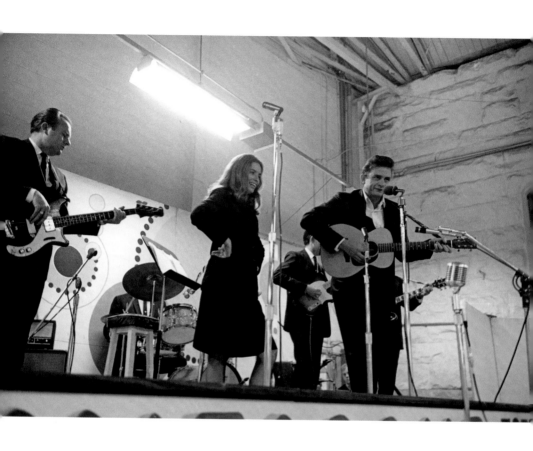

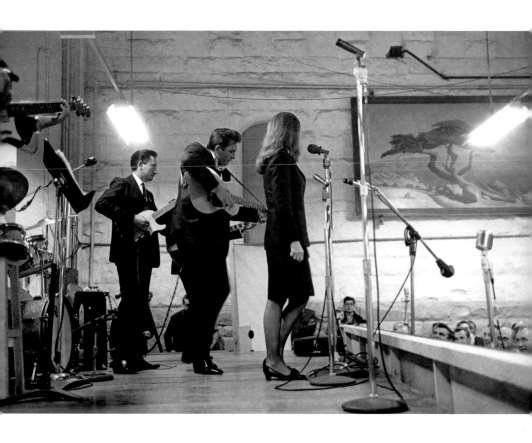

51

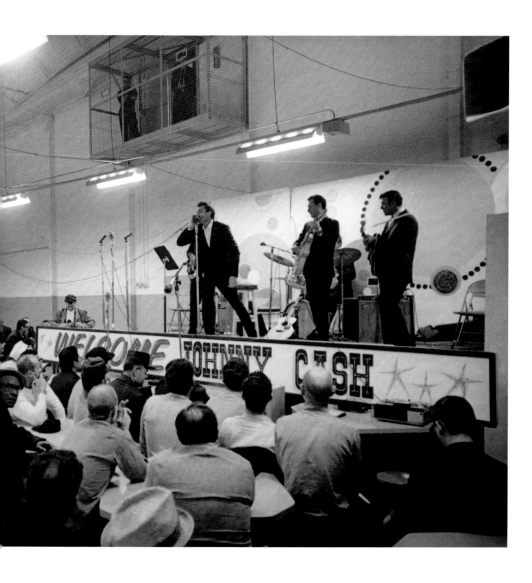

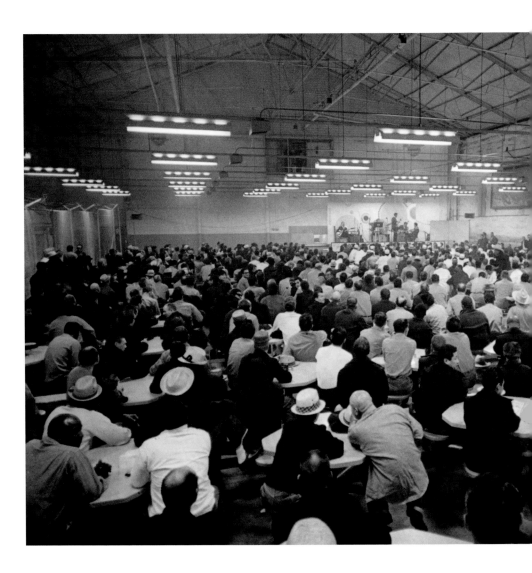

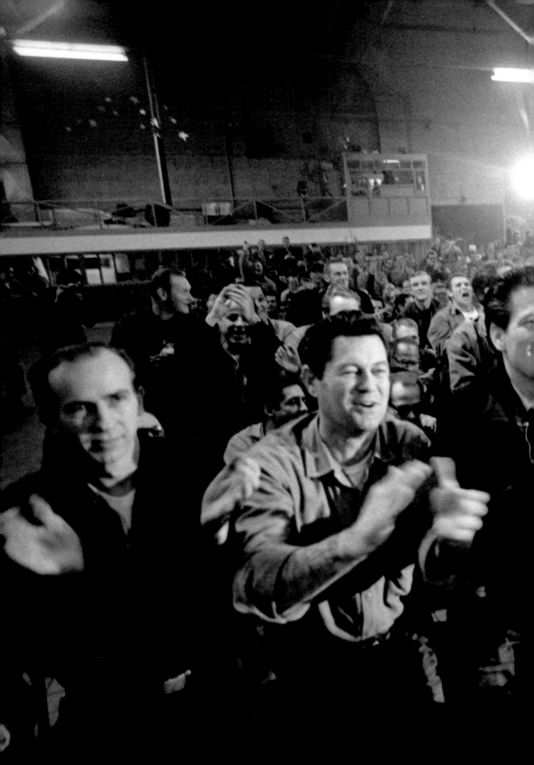

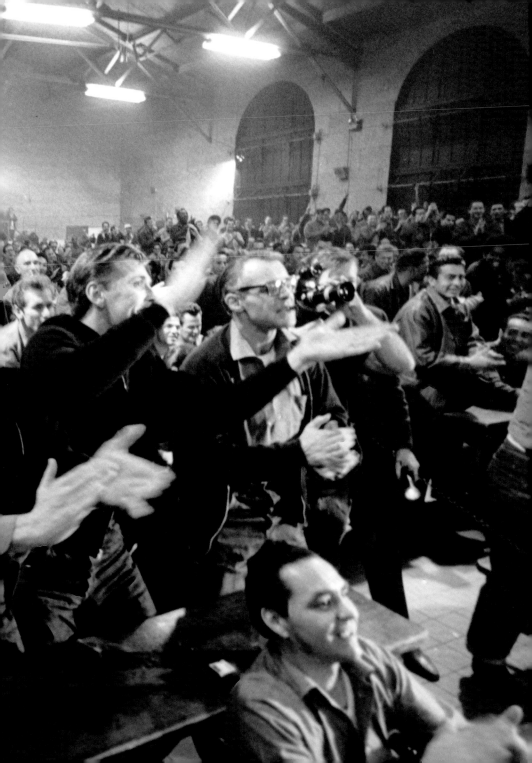

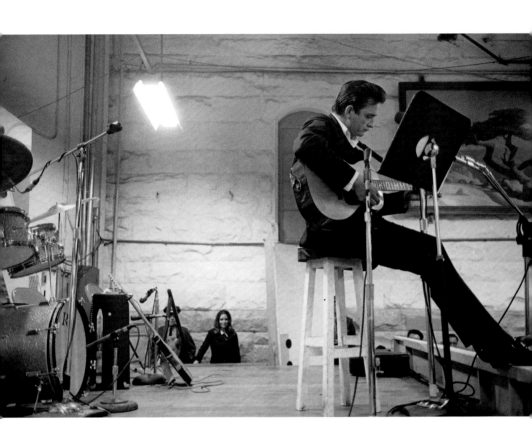

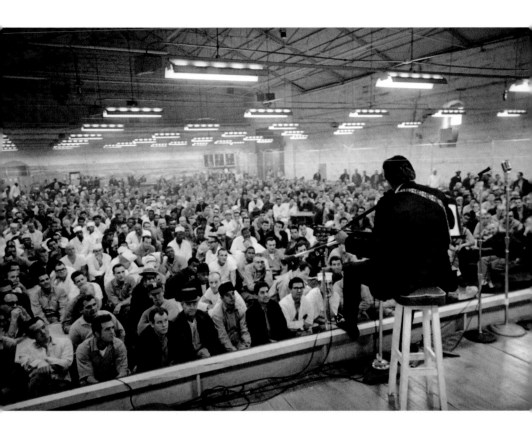

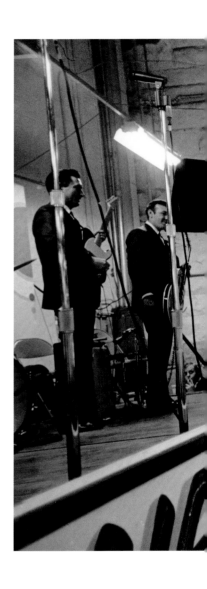

Cash shaking hands with prisoner Glen Sherley, who wrote "Greystone Chapel,"
which was included on the At Folsom Prison *album.*

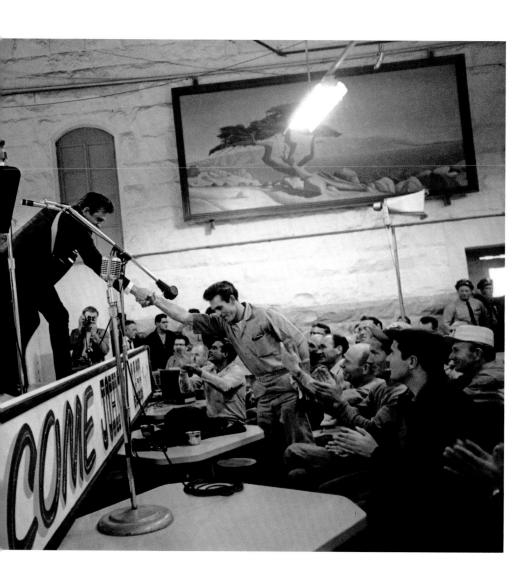

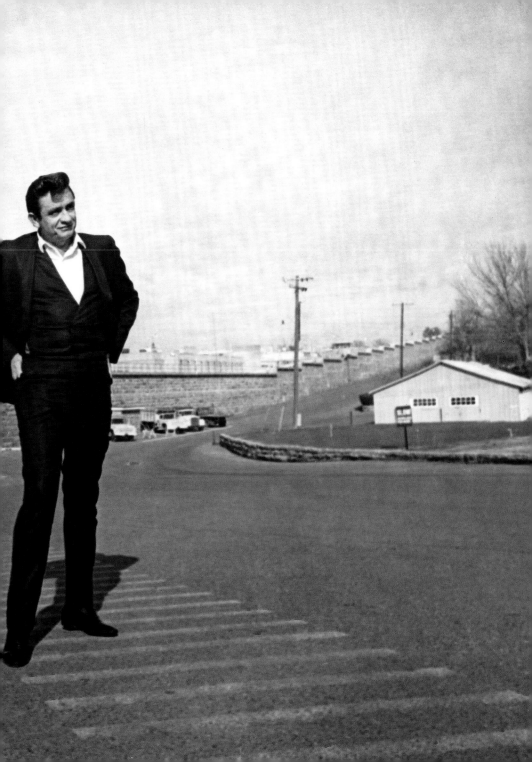

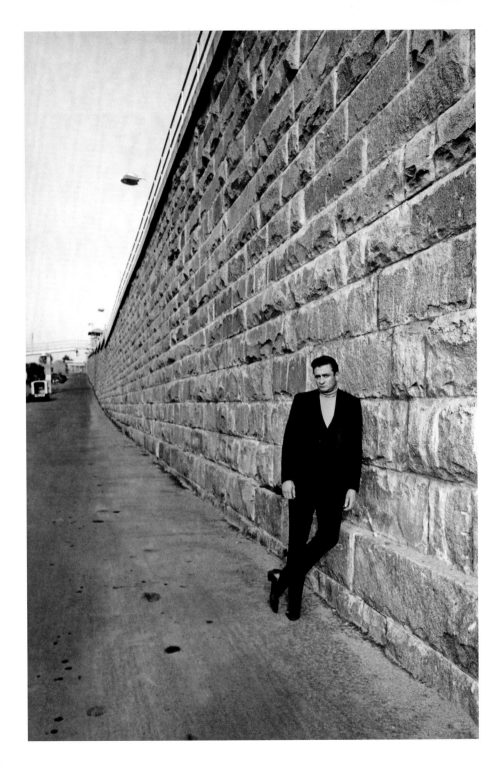

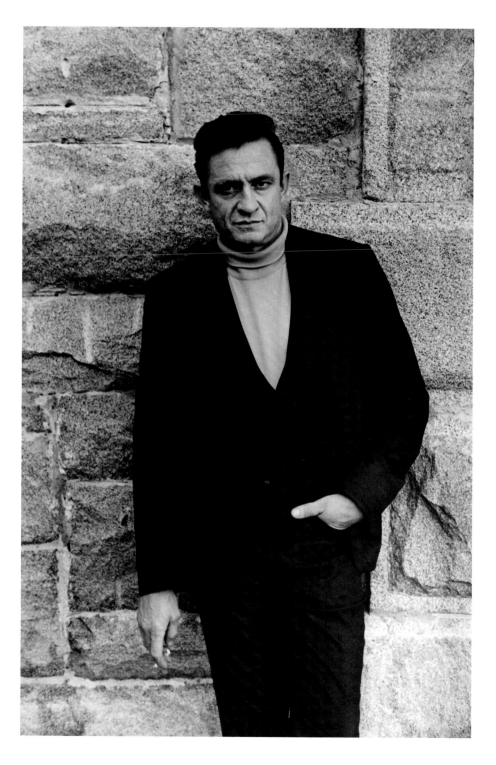

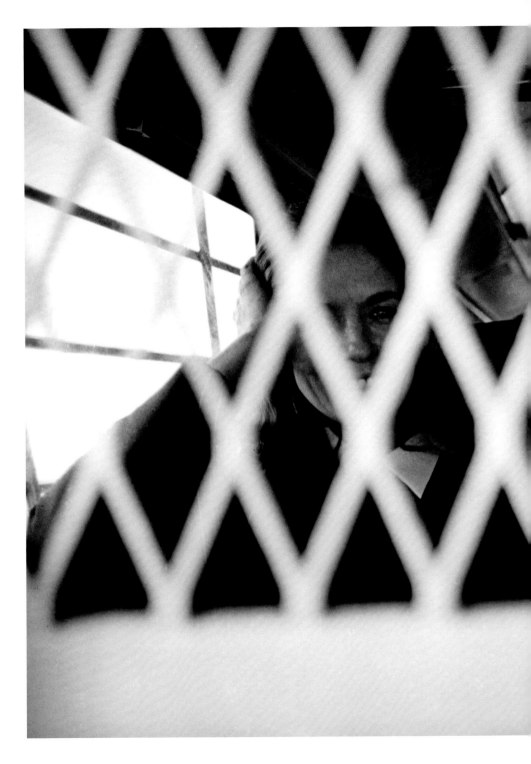

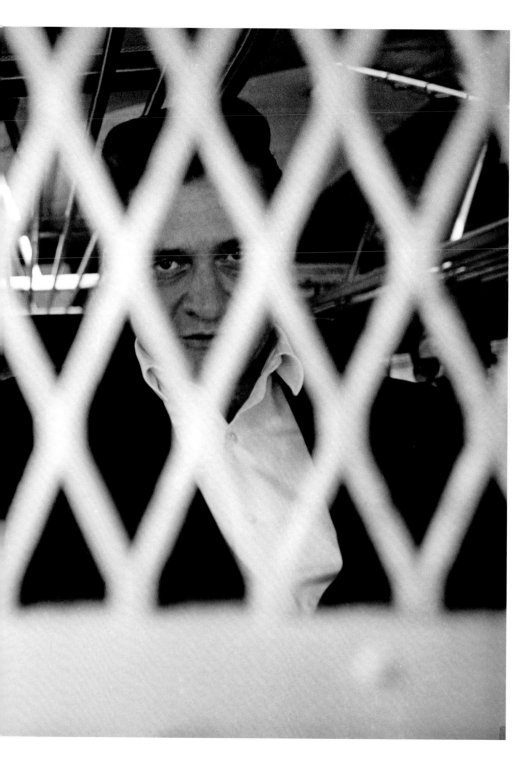

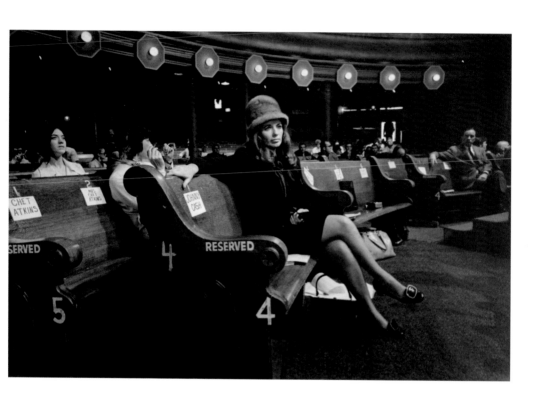

June Carter Cash at the Country Music Association Awards in Nashville, 1969.

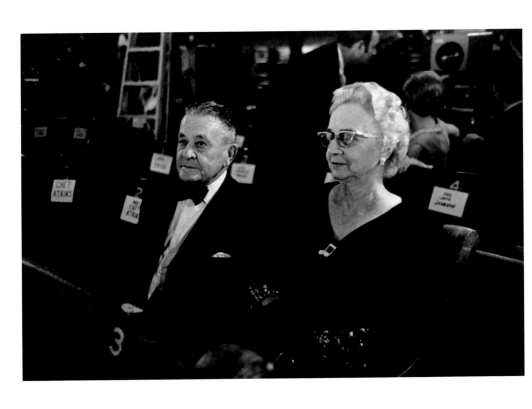

Ray and Carrie Cash, Johnny's parents, at the Country Music Association Awards in Nashville, 1969.

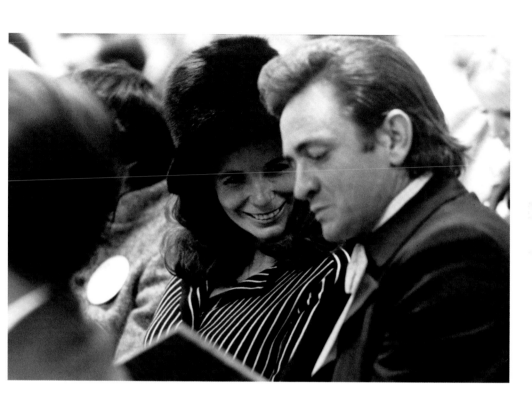

June and Johnny at the Country Music Association Awards in Nashville, 1969.

Rosie Carter and Roseanne Cash.

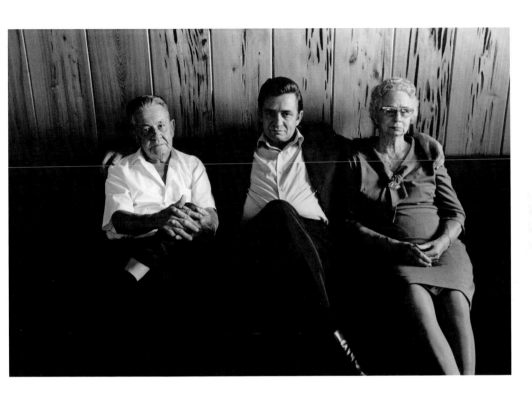

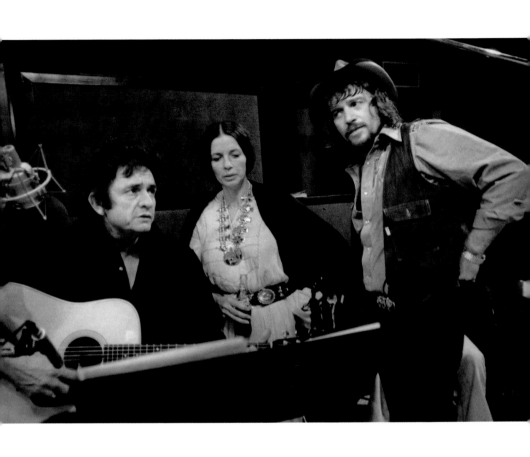

Pages 74-77: With Waylon Jennings in the Cash home studio.

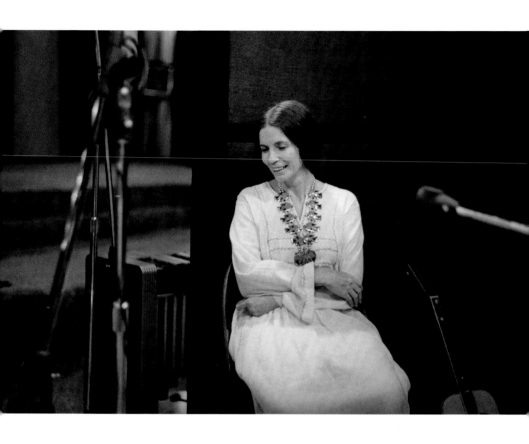

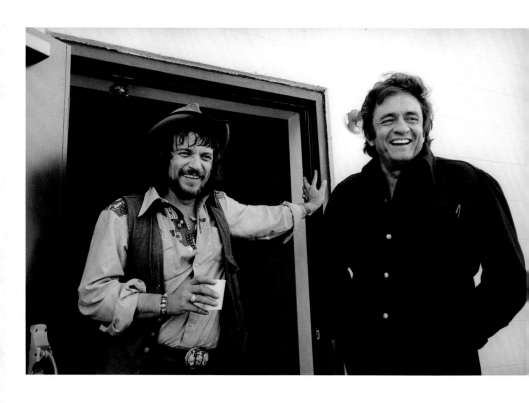

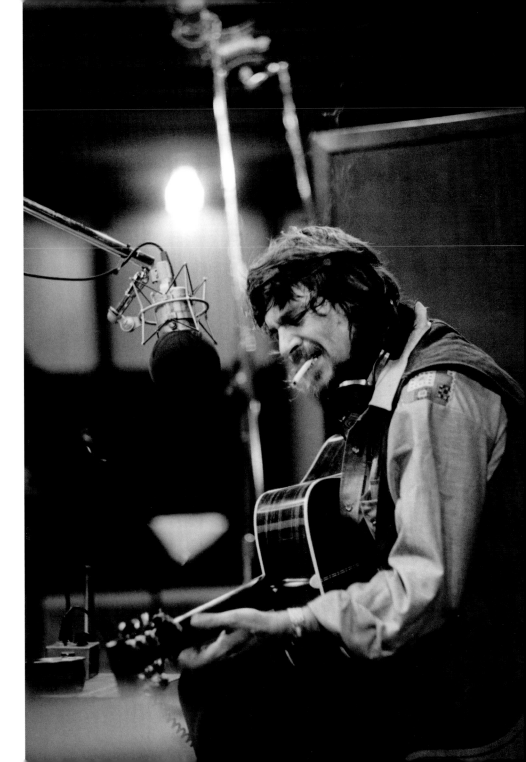

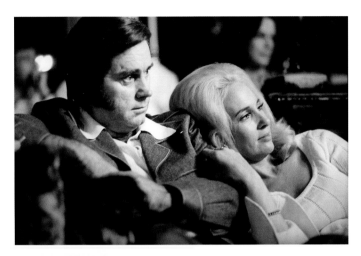

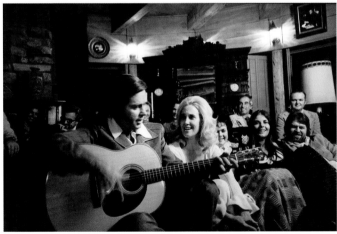

George Jones and his wife Tammy Wynette during Thanksgiving at the Cash home in Hendersonville, 1969.

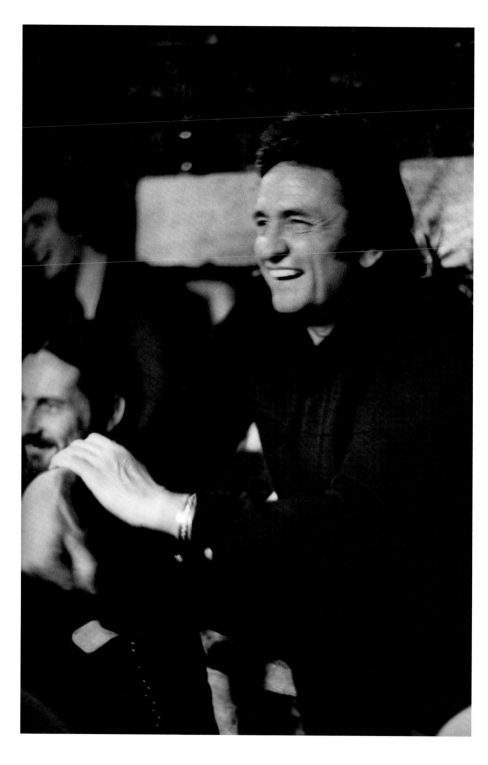

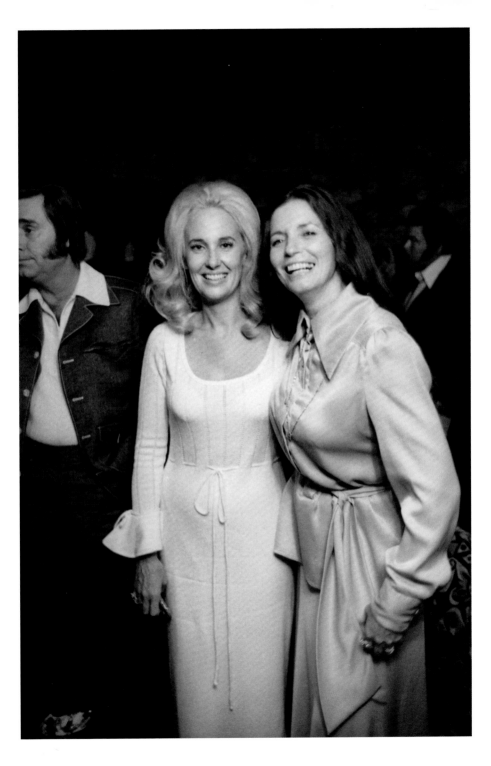

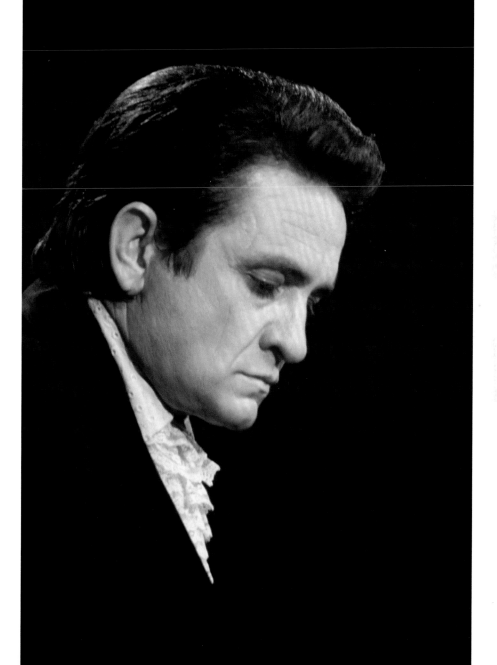

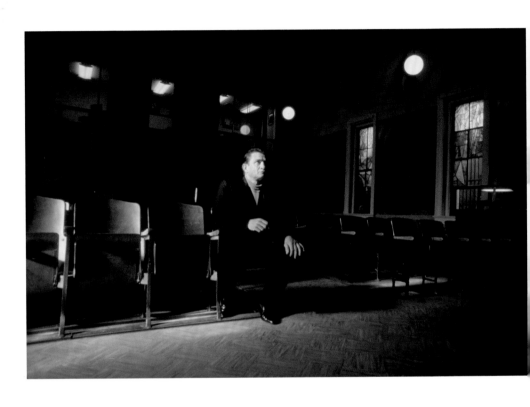

Johnny in Greystone Chapel, Folsom Prison, Represa, CA, 1968.

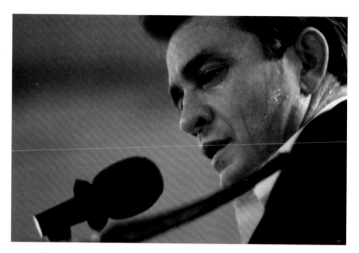

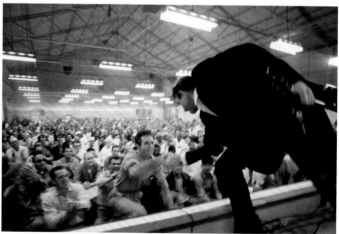

Johnny Cash in performance at Folsom Prison, Represa, CA, 1968.

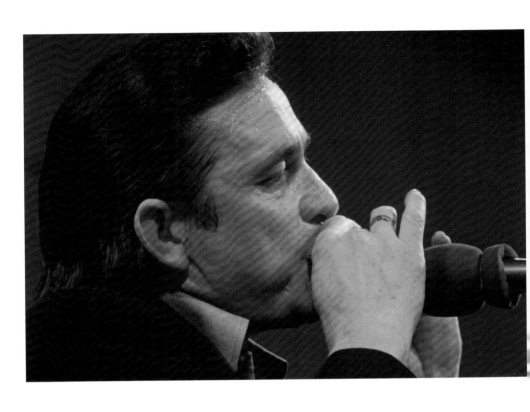

Johnny Cash in performance at San Quentin State Prison, San Quentin, CA, 1969.

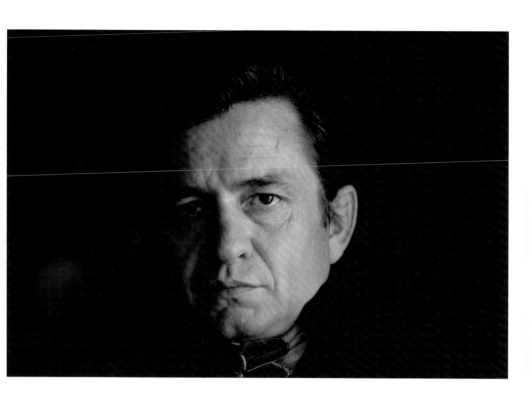

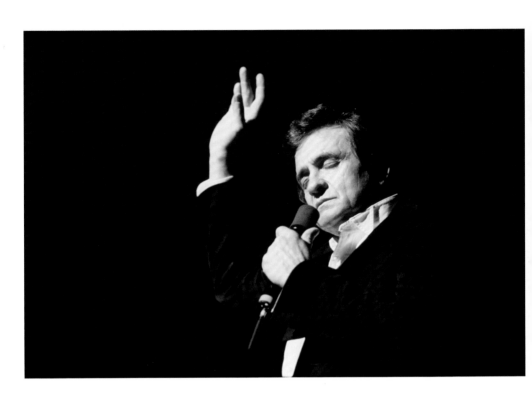

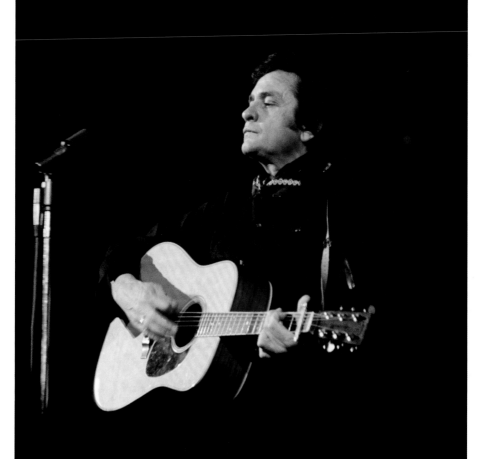

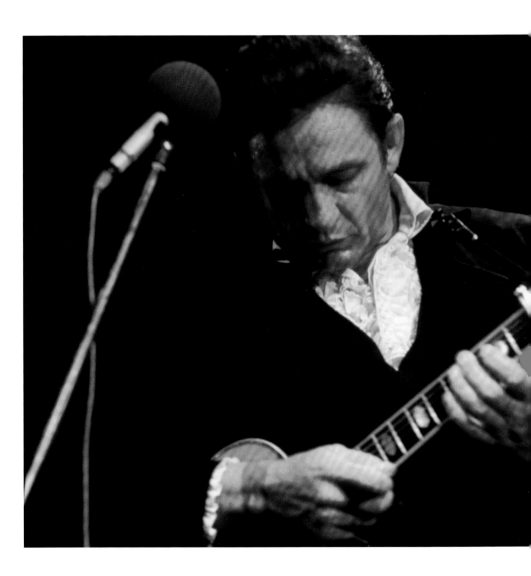

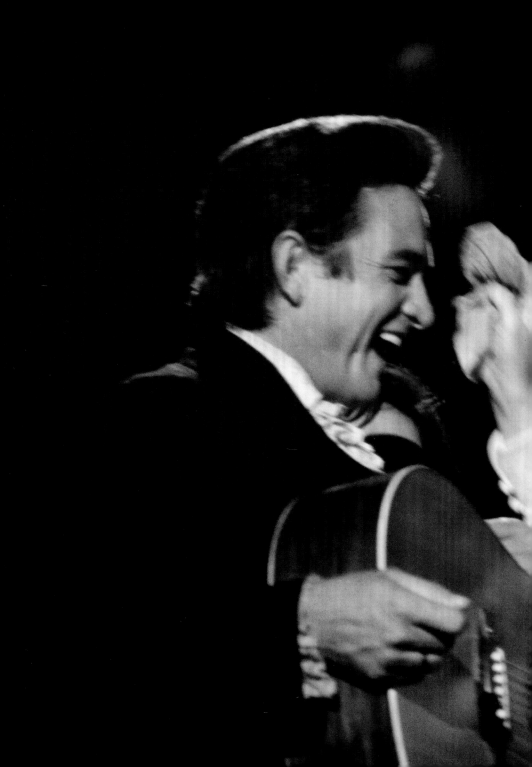

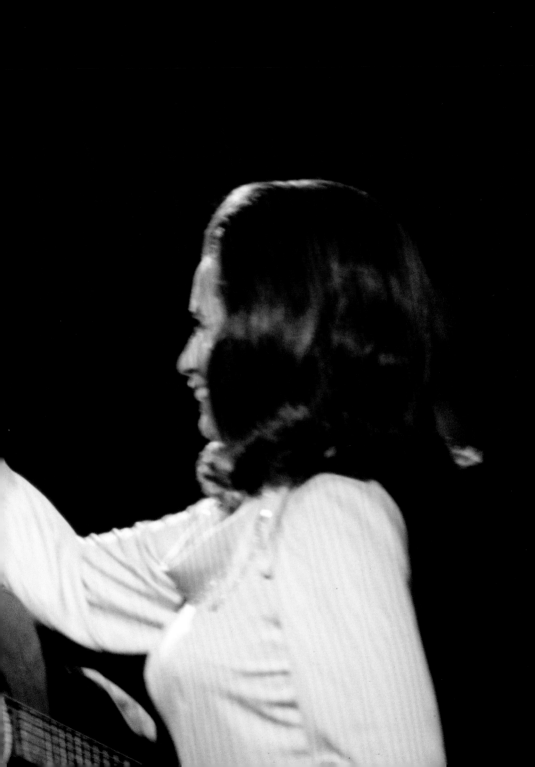

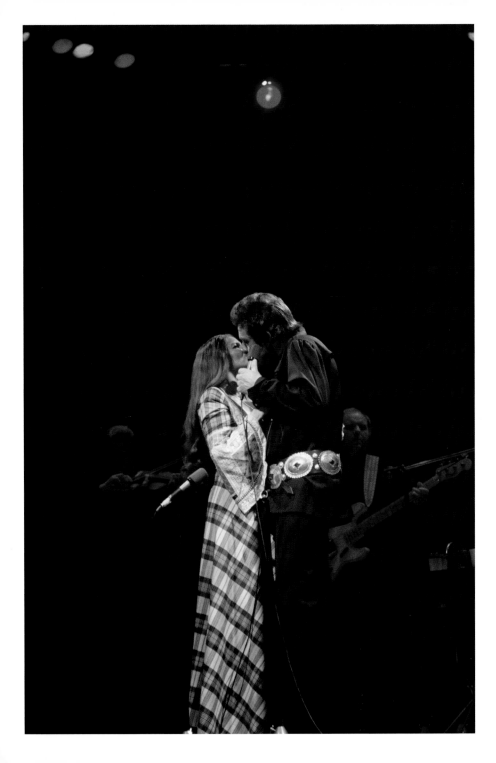

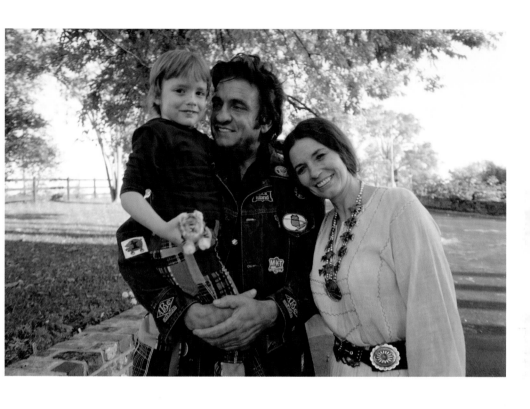

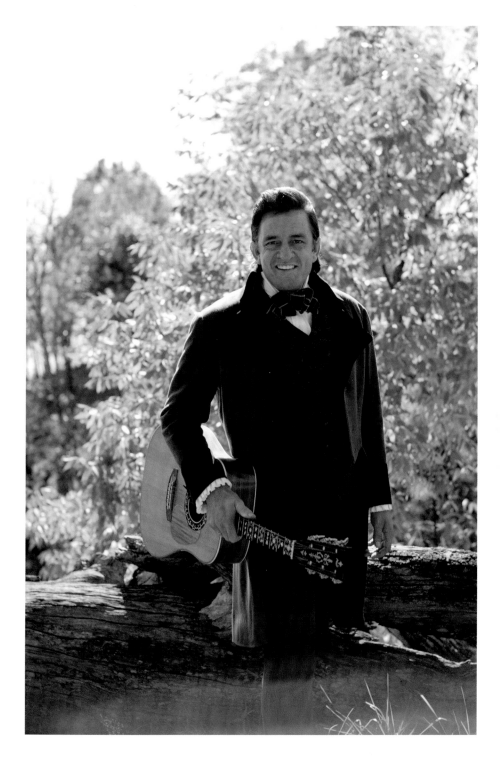

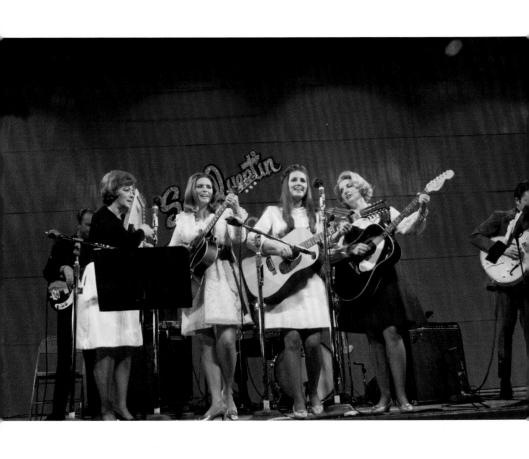

Pages 96–113: Photographs taken at San Quentin State Prison, San Quentin, CA, on February 24, 1969.

LIVE AT SAN QUENTIN PRISON

February 24, 1969

WITH THE SURPRISE SUCCESS of *At Folsom Prison* on both the country and pop charts, Columbia gave Cash the green light to do a second live album, this time recorded at San Quentin State Prison. It was at the sound check for this performance that Jim Marshall made perhaps the most indelible photograph of Cash (p. 99). Warming up, Cash was chatting with the band and with Jim. Jim remembers saying, "Hey, John, how about a picture for the warden?" This unforgettable frame was the result. Like its predecessor, *At San Quentin* was also an immediate success on the country and pop charts; it included Shel Silverstein's "A Boy Named Sue," which reached the top of the country charts as a single and garnered Silverstein a songwriting Grammy in 1970.

Pages 98–101: During rehearsal and soundcheck for the recording session.

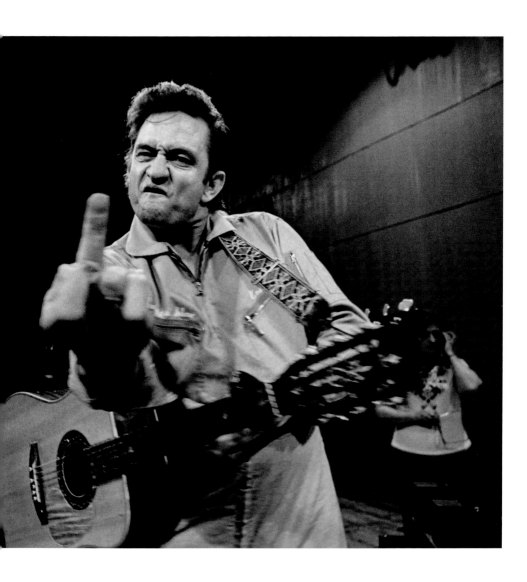

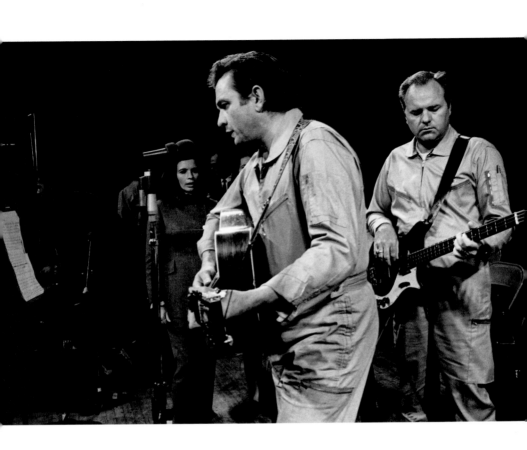

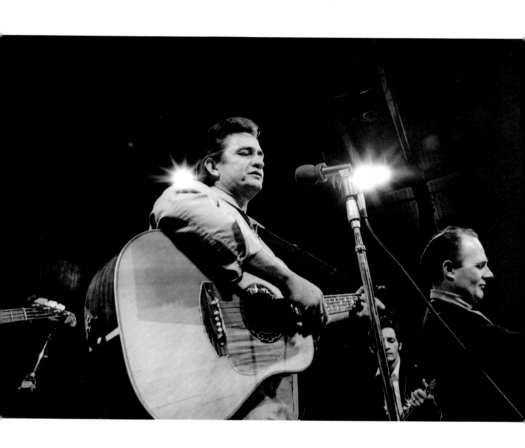

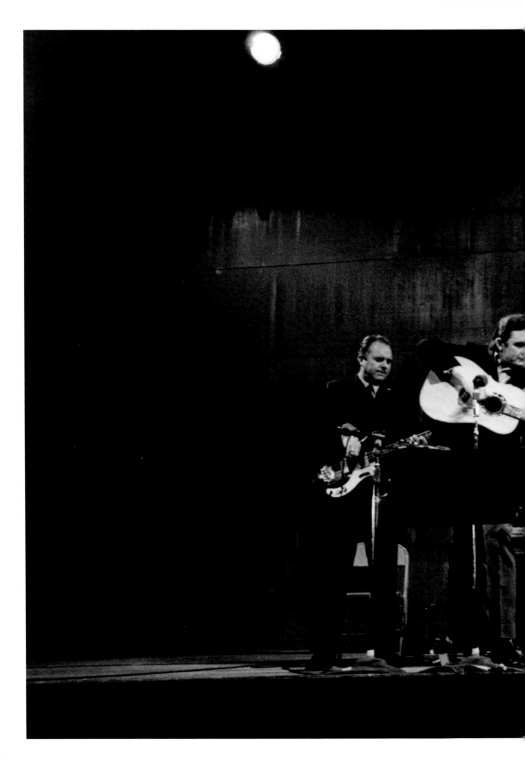

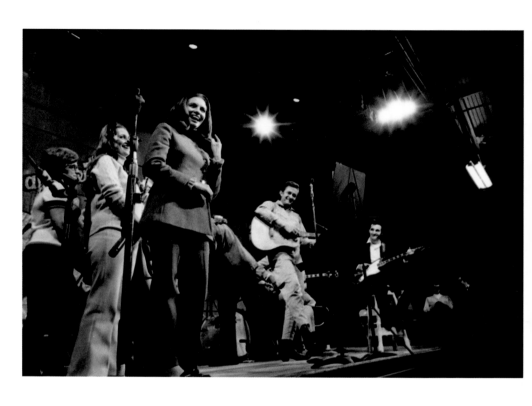

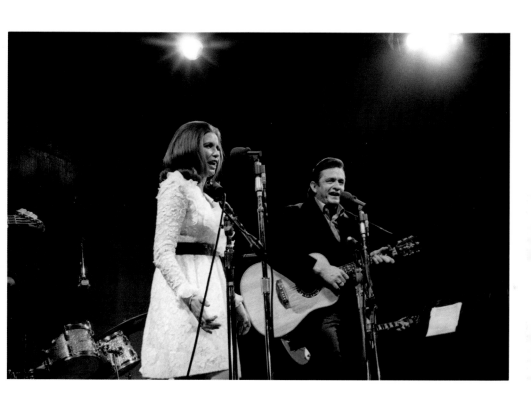

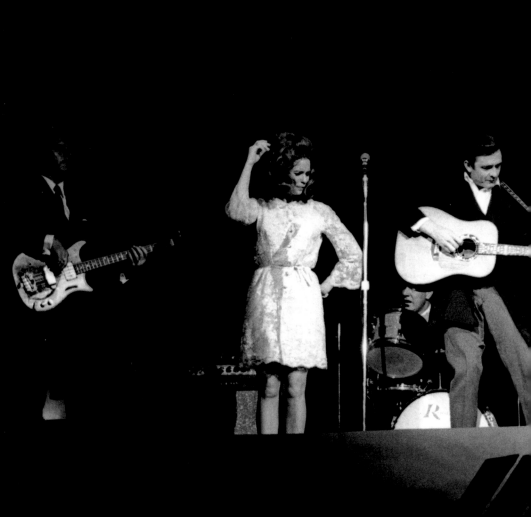

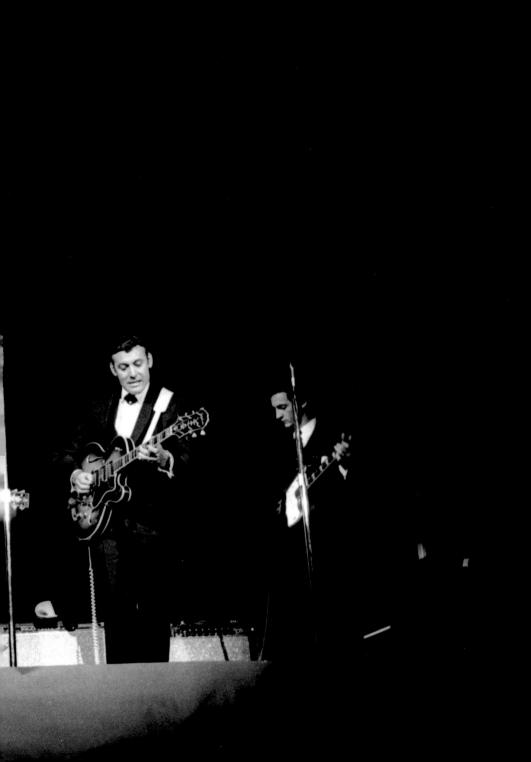

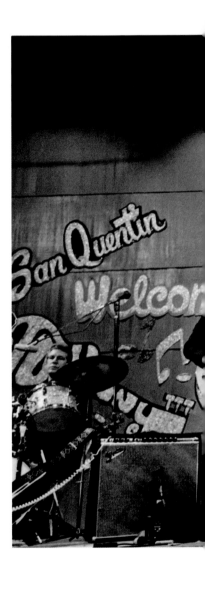

From left, drummer W. S. Holland, guitarist Bobby Wootton, Johnny Cash, and the Statler Brothers.

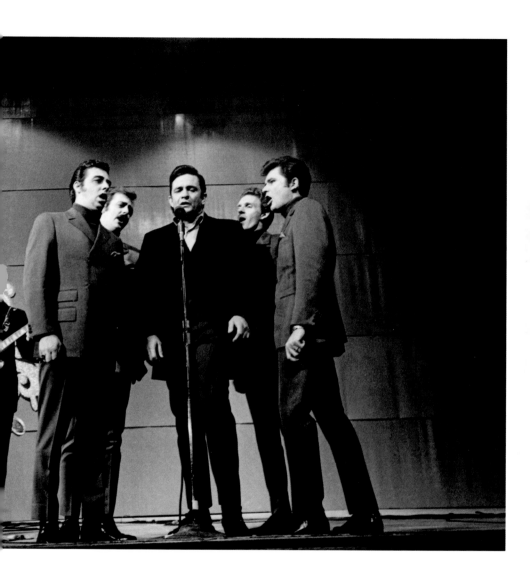

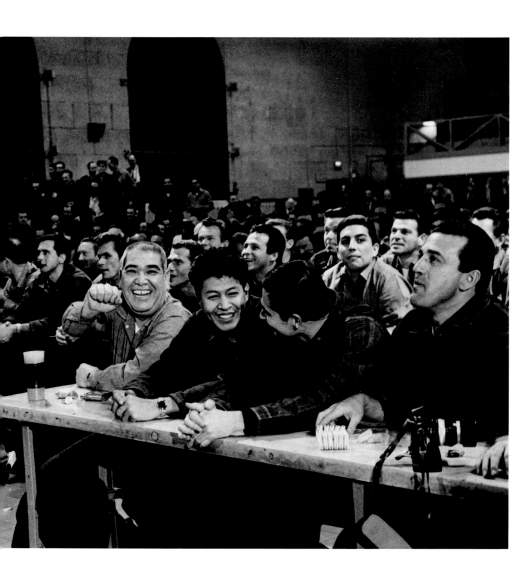

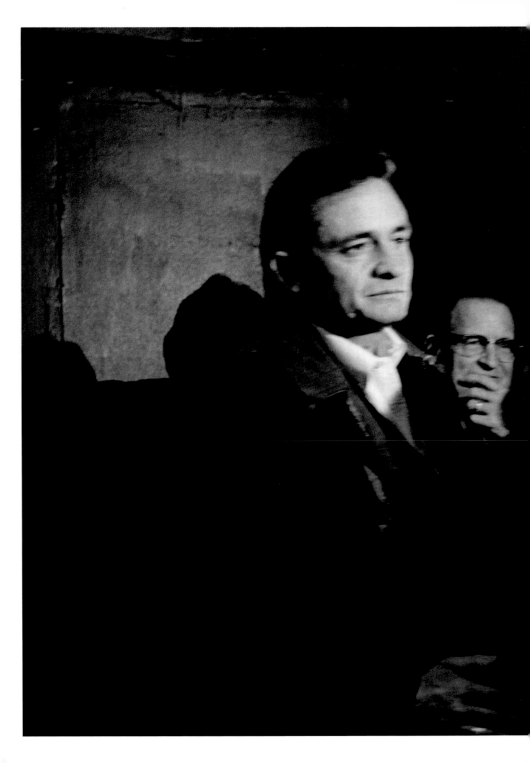

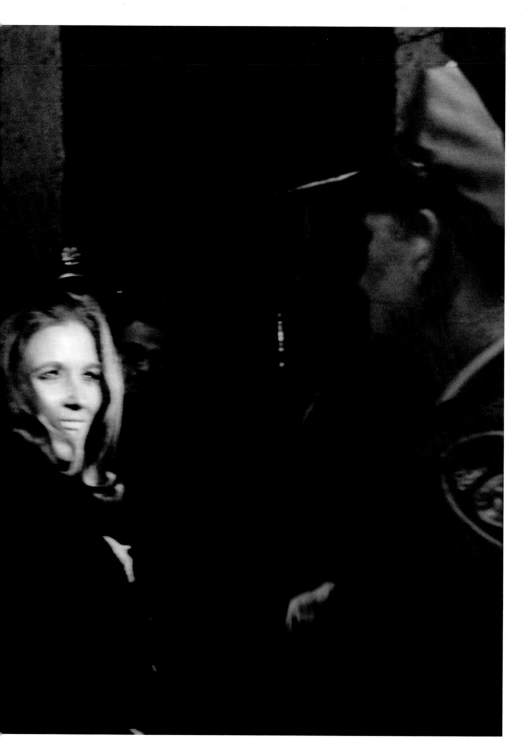

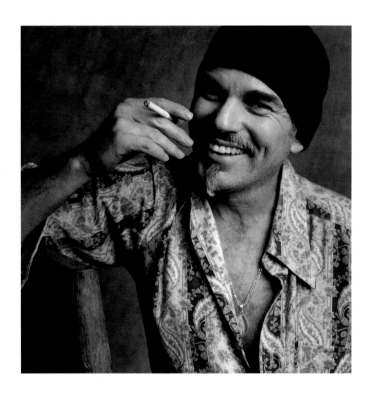

Billy Bob Thornton, Los Angeles, CA, 2003.

REACHING OUT TO SAY HEY

Billy Bob Thorton

THE FIRST TIME I ever heard from Johnny Cash, he left me a message on my voicemail, asking me for a copy of *SlingBlade* and a copy of a movie called *U-Turn*. I couldn't believe a legend like him would know who I was, let alone call for copies of something I'd done. I knew several people who knew him, but I never asked who gave him my number. Also, I figured he had a video store somewhere around his place so maybe he was just reaching out to say hey. Later I learned that was the case.

I had met June Carter a year or two before, through Robert Duvall. I got to know both Johnny and June over the years, and it meant a lot to me to be that close to such amazing, powerful people. I had the opportunity to stay at their place in Tennessee as well as at the Carter Family Home in Virginia.

I have to say I never got over feeling nervous around Cash. I would be talking to him about life growing up in Arkansas, or something like that, and even though he was just being a regular guy, I couldn't quit thinking I was talking to Johnny Cash. He had such power and charisma. It was like I was talking to Benjamin Franklin or Teddy Roosevelt or someone.

He and June were always kind to me and I, along with the rest of the world, miss them very much. Cash was ornery, gentle, smart, country, sophisticated, crazy, incredibly sane, Love, Hate, God; all of it. I was afraid of him, and I loved him. He was his songs.

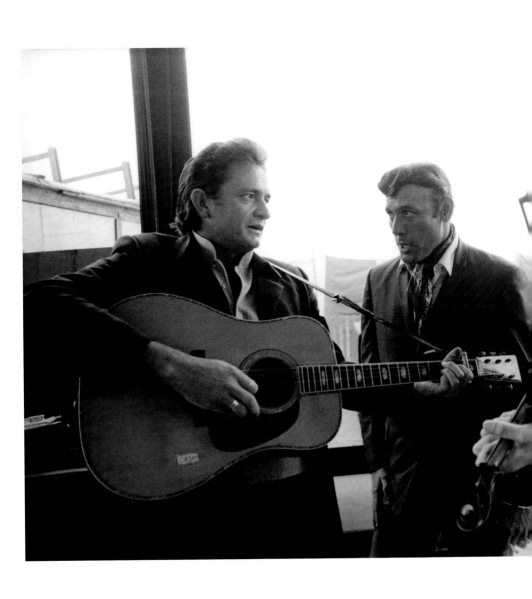

With Carl Perkins and Doug Kershaw, rehearsing at the Newport Folk Festival, 1969.

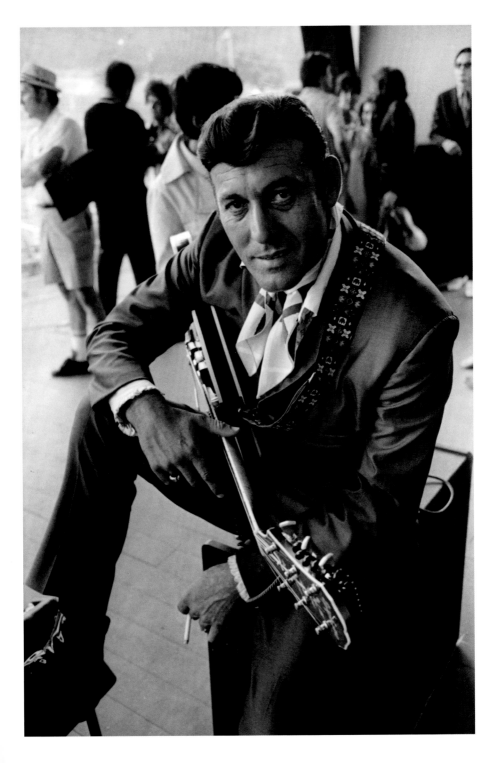

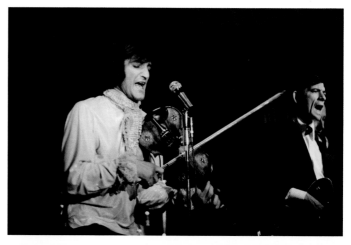

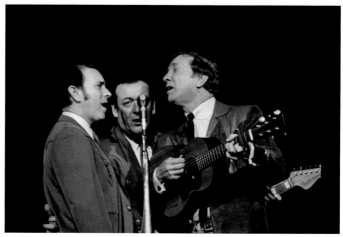

top: Doug Kershaw, Newport Folk Festival, 1969.
bottom: Two singers with Marty Robbins, Newport Folk Festival, 1969.
opposite: Carl Perkins, Newport Folk Festival, 1969.

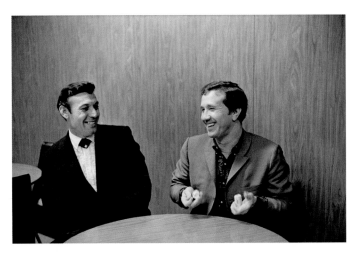

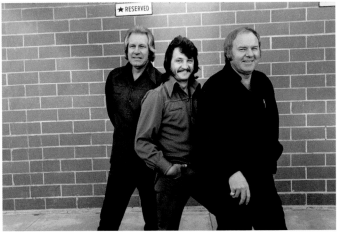

top: Carl Perkins and Marty Robbins, Newport Folk Festival, 1969.
bottom: Marshall Grant, Bobby Wootton, and W. S. Holland, Newport Folk Festival, 1969.

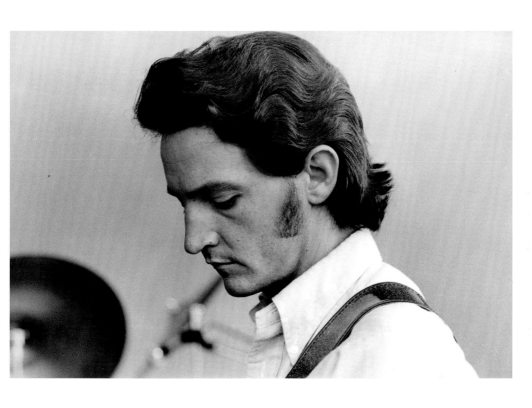

Bobby Wootton, Newport Folk Festival, 1969.

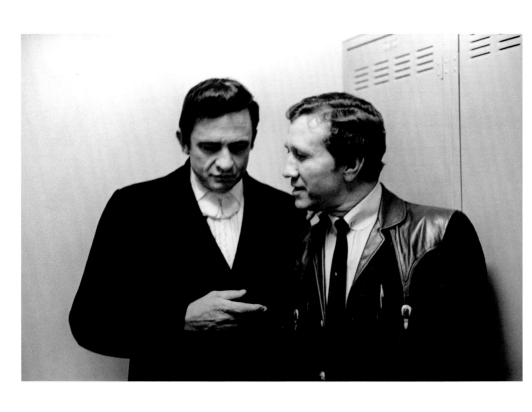

Backstage with Marty Robbins, Grammy Award–winning musician best known for his signature 1959 hit, "El Paso."

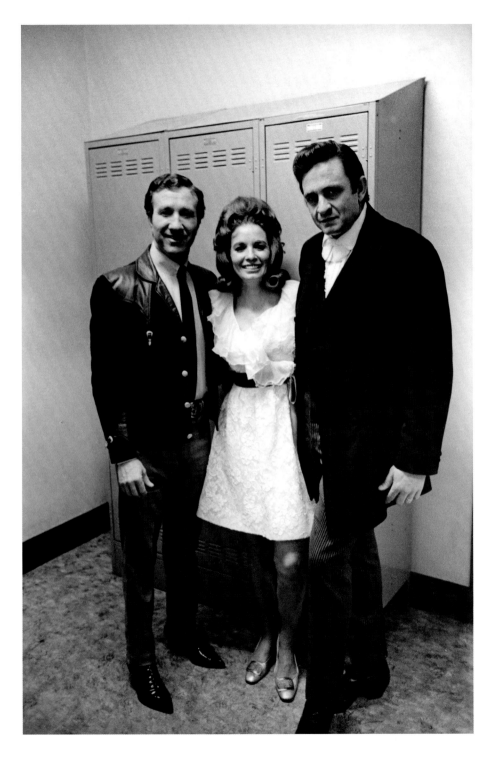

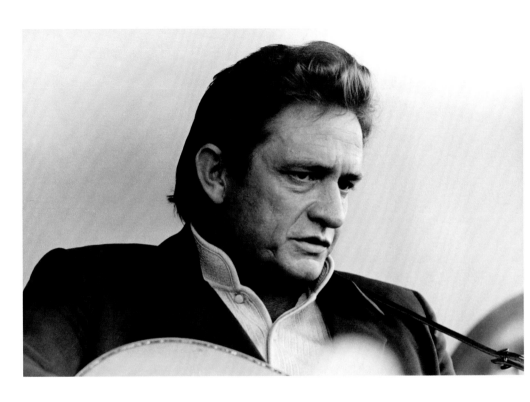

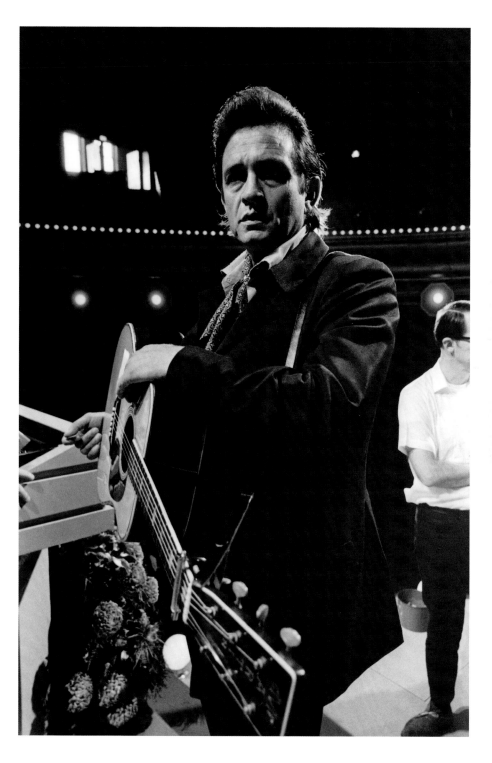

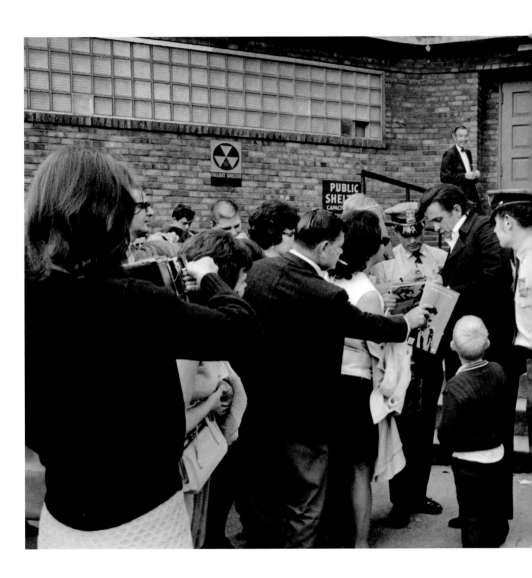

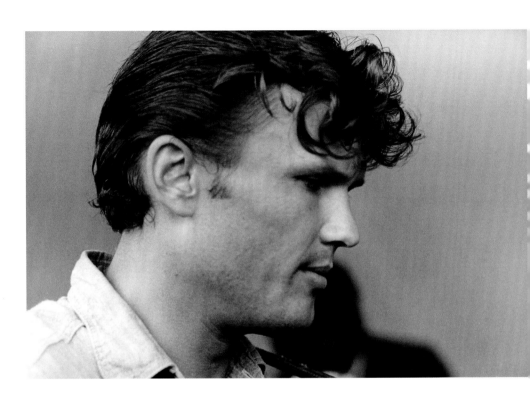

Kris Kristofferson, 1968.

LOOKING BACK

Kris Kristofferson

FORTY YEARS AGO, at the end of the 1960s, the magic was really happening. For those serious souls committed to the creation and performance of honest, original songs, it was the best of times. Bob Dylan had changed pop music forever, elevating it into an art form that combined the reality of artists like Woody Guthrie, Jimmy Rogers, and Hank Williams with absolute freedom of creative imagination. The love and respect Bob shared with Johnny Cash might have been the best thing that happened to both of them. Bob would uncharacteristically perform on the first show of Johnny Cash's television series, which also featured artists like James Taylor, Joni Mitchell, Gordon Lightfoot, Linda Ronstadt, and Ramblin' Jack Elliott. It was a special time.

I met Jim Marshall on the set of *The Johnny Cash Show* in Nashville. Later, when I was in Los Angeles, he drove me, in a rented Volkswagen, to Joan Baez's Monterey Folk Festival and introduced me to her.

Jim was as much a part of that creative time as performing artists were. His work is true to the soul of the music. His pictures are perfect representations of the raw, stark reality of that scene, and they touch me as deeply as the songs.

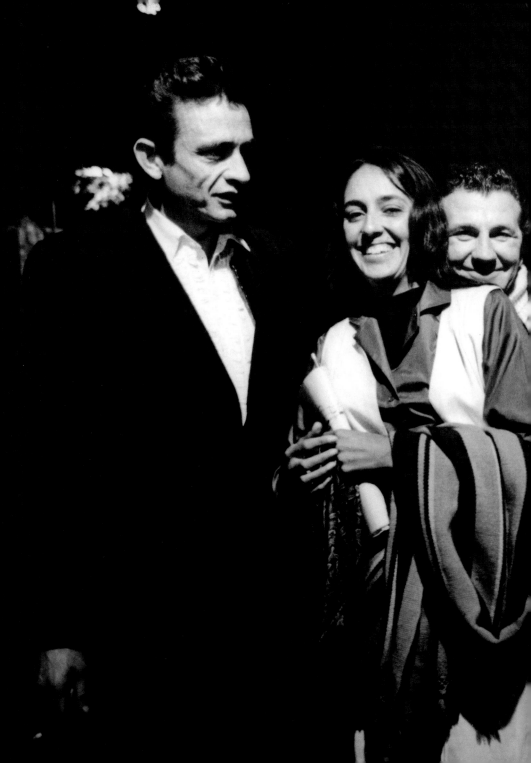

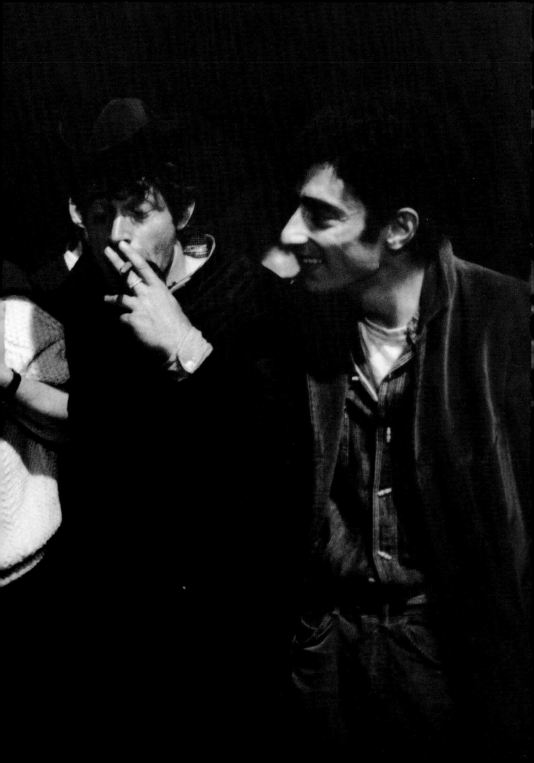

THE JOHNNY CASH SHOW

1969–1971

FROM 1969 TO 1971, *The Johnny Cash Show* aired on the ABC network. The Statler Brothers opened for every episode; the Carter Family and rockabilly legend Carl Perkins were also part of the house entourage. Each show was recorded at Nashville's Ryman Auditorium, then home of the Grand Ole Opry.

On June 7, 1969, Jim Marshall photographed the first episode, featuring Bob Dylan and Joni Mitchell, as well as subsequent performances with Linda Ronstadt, Gordon Lightfoot, Kris Kristofferson, and other notable musicians.

previous spread: Johnny Cash, Joan Baez, Tom Clancy, Bob Dylan, and John Herald, Greenwich Village, New York, 1963.

opposite: On the set of The Johnny Cash Show

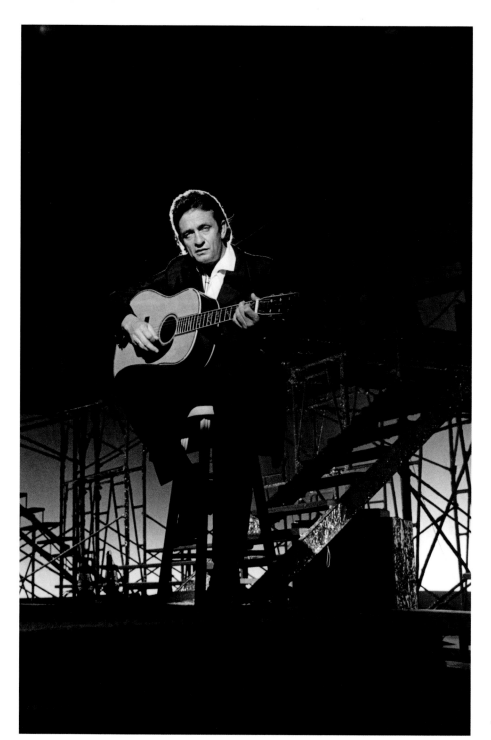

Bob Dylan in rehearsals for The Johnny Cash Show, *June 1969.*

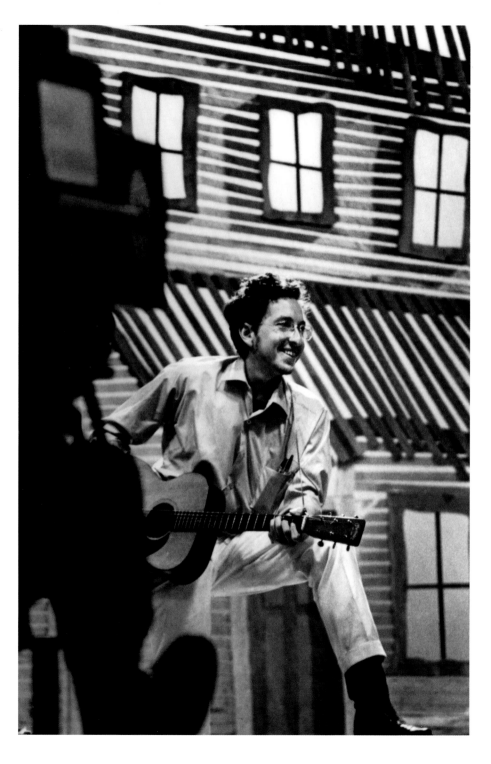

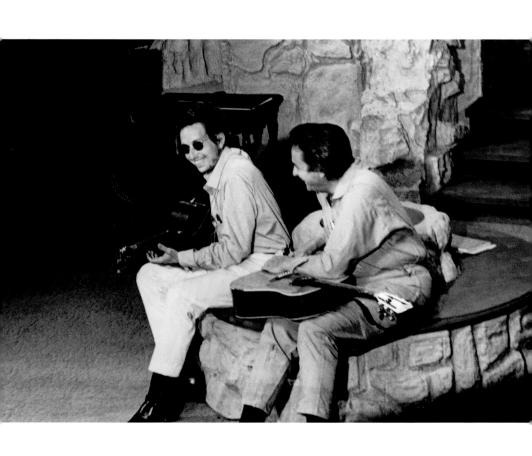

With Bob Dylan in rehearsals for The Johnny Cash Show, *June 1969.*

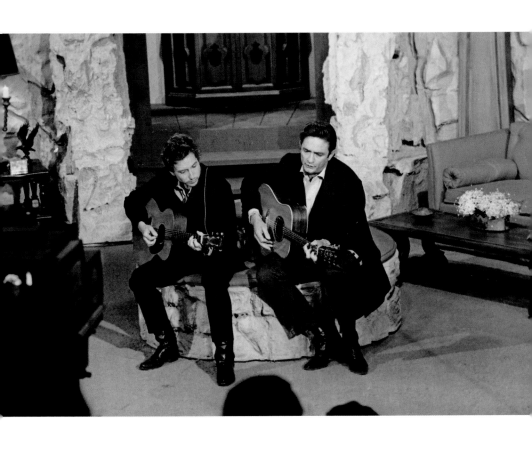

With Bob Dylan, performing for The Johnny Cash Show, *aired June 7, 1969.*

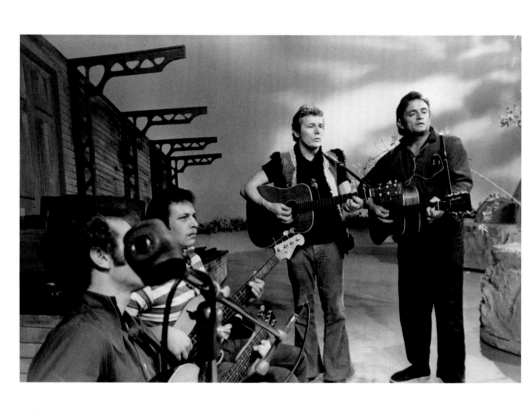

With Gordon Lightfoot in rehearsal for The Johnny Cash Show, *aired June 14, 1969.*

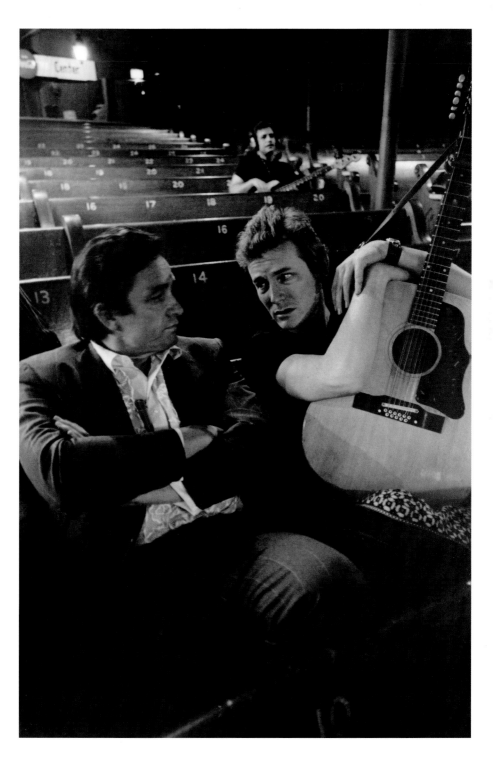

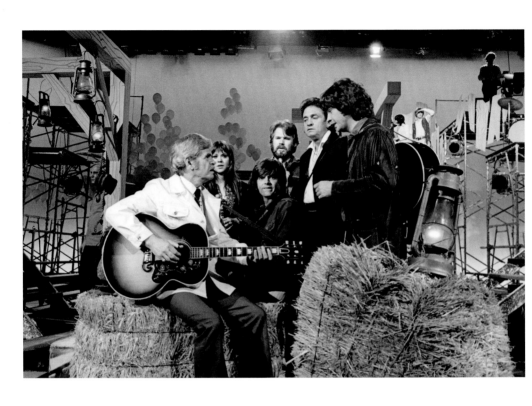

Ike Everly, rehearsing with Don and Phil Everly (The Everly Brothers) for the
Johnny Cash Christmas Show, *aired December 1970.*

following spread: Carl Perkins, Glen Campbell, and Linda Ronstadt rehearsing for
The Johnny Cash Show, *1969.*

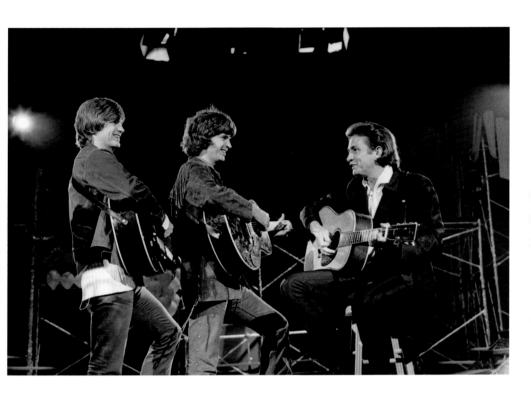

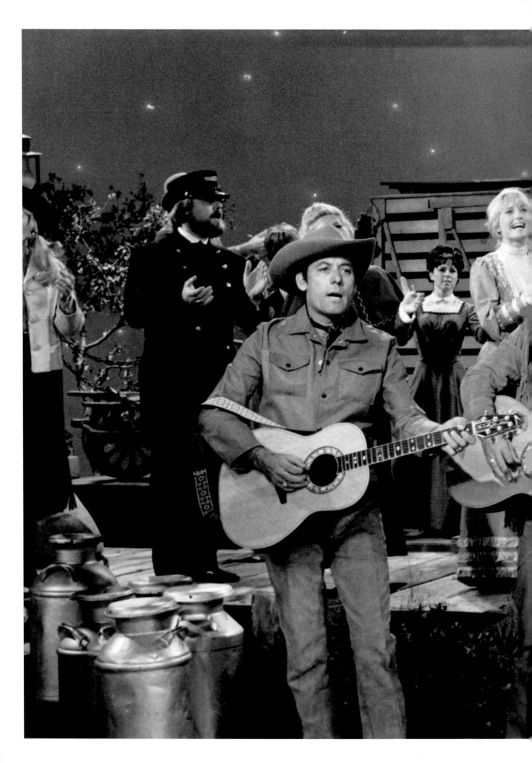

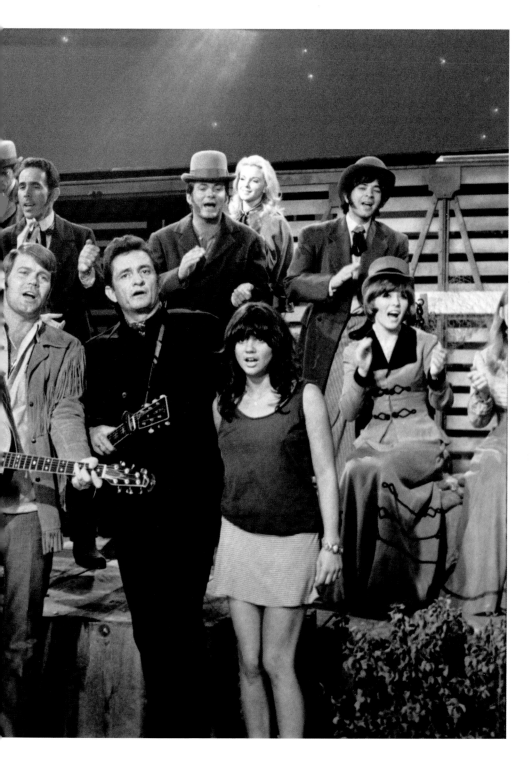

Pages 147–149: Johnny in his home studio with John Carter Cash, Hendersonville, TN.

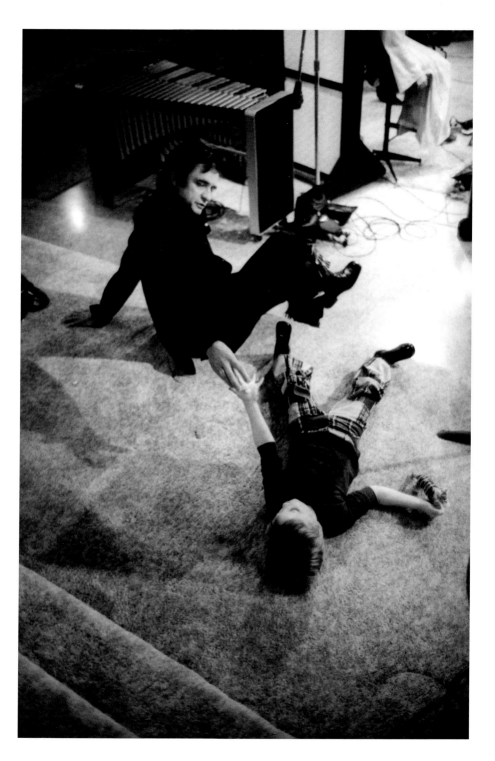

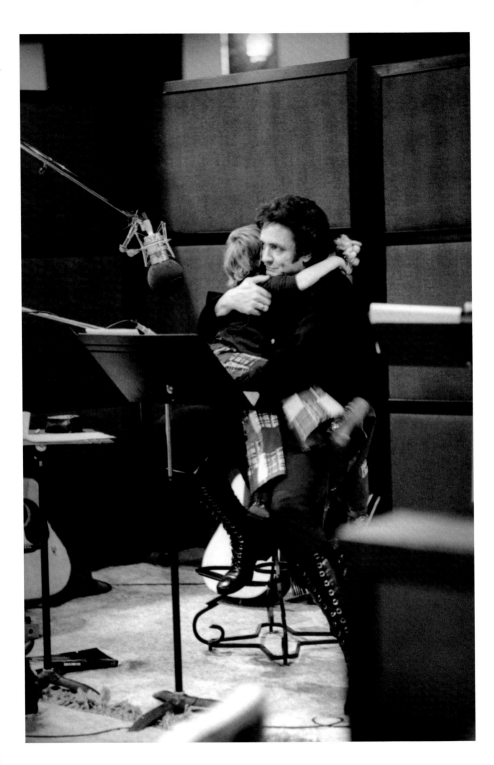

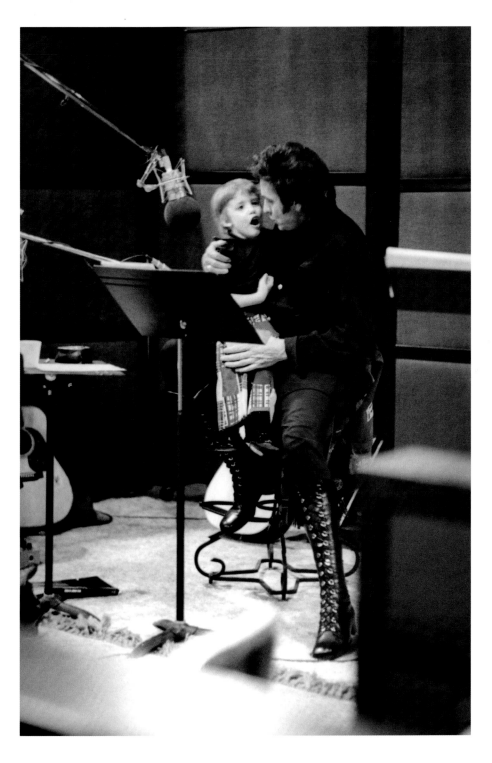

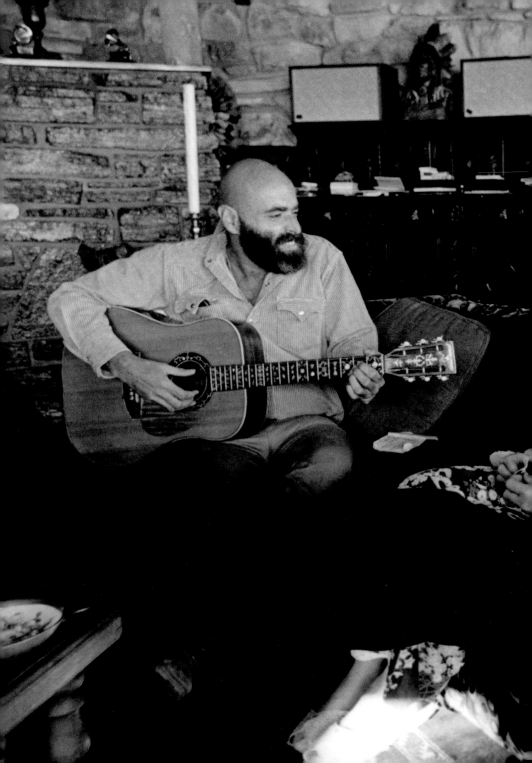

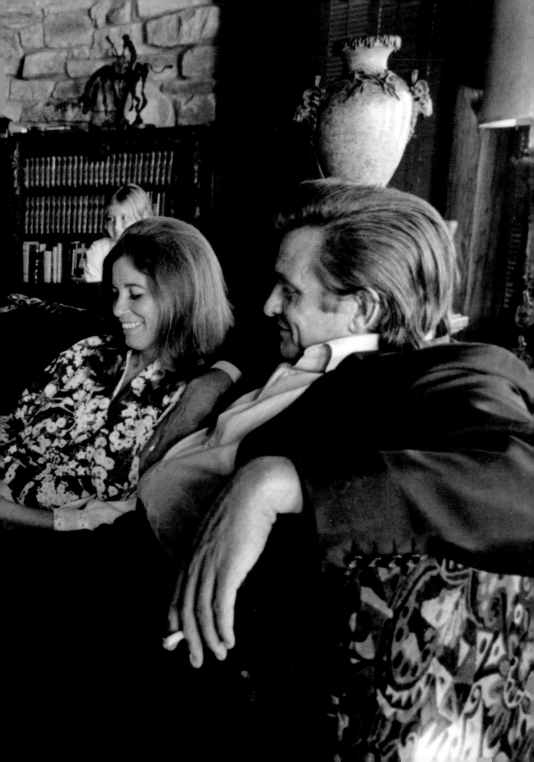

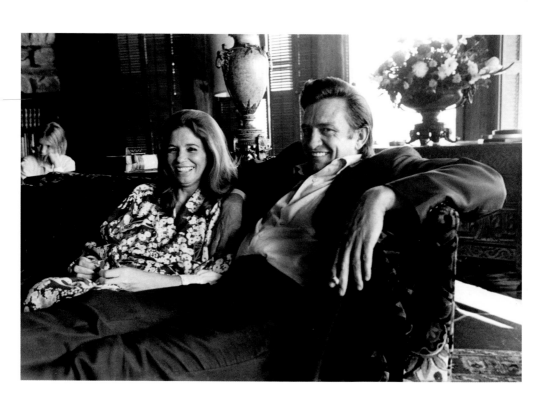

previous spread: Shel Silverstein with June and Johnny at their home in Hendersonville.

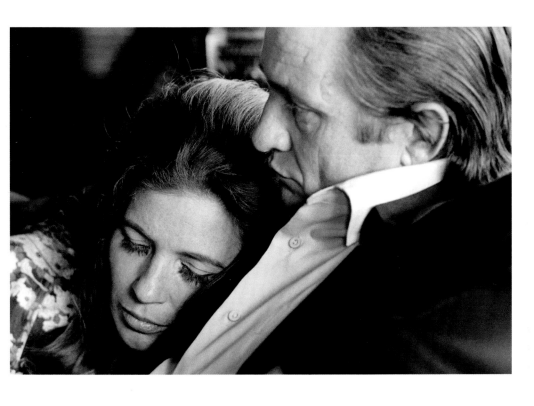

SELECT CHRONOLOGY

1932 Johnny Cash born in Kingsland, Arkansas, February 26; grows up in Dyess.

1950–54 Serves in the air force, primarily stationed in Germany, and begins writing songs.

1954 Marries Vivian Liberto; settles in Memphis.

1955 First recording session at Sun Records, March 22, results in the release of "Cry, Cry, Cry"; "Folsom Prison Blues" released in December. Daughter Roseanne Cash born.

1956 "Walk the Line" climbs to the top of the country charts.

1957 Cash and the Tennessee Two accept an invitation to perform at the Huntsville State Prison in Texas.

1959 Cash moves to Los Angeles; joins with Columbia Records. He and the band perform at San Quentin State Prison, California, on New Year's Day, inspiring inmate Merle Haggard to go on to his own career in country music. Also records *Bitter Tears,* the first of his concept albums.

1962 The Carter Family joins the touring *Johnny Cash Show.*

1963 Records "Ring of Fire," written by June Carter with Merle Kilgore.

1964 Bob Dylan and Cash meet at the Newport Folk Festival, where they are both performing.

1967	Bob Dylan and Simon and Garfunkel's record producer, Bob Johnston, assumes production of Cash's recordings and supports Cash's desire to record a live album at Folsom Prison.
1968	Two recording sessions on January 13 result in the album *At Folsom Prison*; Jim Marshall is there photographing for Columbia Records at the request of Johnny Cash.
	Cash and June Carter receive a Grammy award for "Jackson." John proposes to June onstage in February, and they marry in March.
1970	Son John Carter Cash is born.
1975	Johnny Cash's first autobiography, *The Man in Black,* is published.
1980	Elected to the Country Music Hall of Fame.
1985–95	Cash, with Waylon Jennings, Kris Kristofferson, and Willie Nelson performs and records as the Highwaymen.
1994	Develops *American Recordings* album with producer Rick Rubin, known for his work with the Red Hot Chili Peppers and the Beastie Boys.
1994–95	Receives the Kennedy Center Award.
1999	June Carter Cash receives a Grammy award for her solo album, *Press On*.
2003	June Carter Cash passes away; Johnny dies four months later.

AFTERWORD

Jim Marshall

I FIRST MET JOHNNY CASH when he was hanging out with Bob Dylan at some Greenwich Village nightclub in 1962. We just hit it off. I photographed him at the Newport Folk Festivals. When I came back out to San Francisco in '64, we stayed in touch.

When Columbia Records agreed to do the Folsom Prison shows—producer Bob Johnston talked them into doing it—John called them to have me shoot the concerts. There was one other photographer there; I don't know if he even got inside. I had unlimited access at Folsom; I could go anywhere I wanted. Pop music writer Bob Hilburn of the *Los Angeles Times* was there—one of his first assignments for the paper. He's in some of the photos. The album, *At Folsom Prison,* was recorded on a four-track. John brought his whole show—the Statler Brothers, Mother Maybelle Carter, and Carl Perkins, with the Tennessee Three.

Cash stepped down off the bus just as the steel doors to the prison clanged shut and said, "There's a feeling of permanence to that sound." He went into Greystone Chapel and meditated, prayed there for a little bit. It was small, held maybe forty, fifty people. He was going to record a song called "Greystone Chapel" written by one of the inmates, Glen Sherley. He cared about the prisoners a lot. He cared about the conditions and tried to help improve them. Johnny was never in prison. He got busted once for being drunk, peeing on the sidewalk, something like that—big deal—but never for a serious crime. The myth of Johnny is not the man.

Later, they asked me to go to San Quentin. They used somebody else's shot for the album cover, more stylized. The shots on the back are mine. San Quentin is where I got the finger at the sound check. That is probably the most ripped off photograph in the history of the world. There was a TV

crew behind me and John was on the side of the stage. I said "John, let's do a shot for the warden." He flipped out the bird. Three frames, a .21 millimeter lens. I don't know if the film crew caught it. Elton John bought all three frames.

Billy Roberts, who wrote "Hey Joe," and I had written a song called "Hang Out with Me." It was a folk song. I wanted John and June to cut it. They invited us down for Thanksgiving, along with Tom Jans, who wrote "Lovin' Arms." Johnny cut that for Tommy. They cut "Hang Out With Me" like a ballad. I was too intimidated by Cash to say "Hey, do it like 'Jackson.'" What can you say to Cash?

I went down to photograph the first episode of the ABC-TV series, *The Johnny Cash Show*, at Ryman Auditorium, home of Nashville's Grand Ole Opry. It was a very big deal—Dylan's first public appearance since his motorcycle crash. At the rehearsal, one of Dylan's men came up to me and said "Bobby doesn't want any pictures taken." I said, "Bobby knows me well enough that he could come up and ask me personally." "That's not the way he does things," the guy said.

Just at that moment, June Carter comes by. Our voices were getting a little hot. June said, in a very sweet voice, "Jim, what's the matter?" "We don't want any photos taken," Dylan's guy said. "Well, son," June said, "Who are you?" "I'm with Bob Dylan," he said. "Jim is with me," she said. "This is my TV show. Jim is my photographer and he can do whatever he wants." Who's going to say anything to June Carter? Dylan didn't say shit. I shot the two of them from about ten feet away.

Over the years, I've done record covers with John, magazine spreads. I can't remember which ones. We're talking about thirty years of photographs. I did Waylon Jennings at the house with him. A couple of Johnny's kids

came by. Shot them. Shot his mom and dad with him at the house. Felt very comfortable. John trusted me.

Funny story—about five years ago I got a call from Steve Bing to shoot Jerry Lee Lewis in Nashville. Over the years our paths never crossed and yet Jerry had photographs of mine—Kristofferson, Cash, Waylon, Carl Perkins—in his house. Jerry said, "Jim, I've got to ask you a serious question. What took you so damn long to get around to me?"

Johnny had an edge. When John walked in a room, you knew he was there. There was a hint of danger, but I don't think he was a violent man. You just knew he was there. He had a presence that very few artists have. I think it shows in the photographs.

He didn't suffer fools gladly. He kept a close bunch of friends that were very tight to him. The people who loved him, loved him fiercely, and vice versa. His wife, June Carter, was his lifeline. I remember when they got back together, about a year before the Folsom concerts. He stopped doing drugs. June kept him off the drugs and saved his life. I think the day she died, he died.

—February 24, 2010

ACKNOWLEDGMENTS

I am grateful to John Carter Cash for his beautiful introduction and his endorsement of this project. Thanks also to Kris Kristofferson and Billy Bob Thornton for their contributions, and to Joel Selvin for working with me on my text.

My assistant, Amelia Davis, and Bonita Passarelli are always there to help out with what needs to be done, and I appreciate their support and friendship. Kirk Anspach, as always, made the silver prints for this book; they were ably reproduced through the efforts of separator Thomas Palmer. Brooke Johnson did a great job on the design of the book; I want to thank her, Tera Killip, Becca Cohen, my editor Michelle Dunn Marsh, and Nion McEvoy of Chronicle Books for continuing our years of work together.

—Jim Marshall

In Memoriam **JIM MARSHALL** *1936–2010*

Library of Congress Cataloging-in-Publication Data available.
ISBN: 978-0-8118-7562-2

Manufactured in China.

Design by Brooke Johnson.

10 9 8 7 6 5 4 3 2 1

Chronicle Books LLC
680 Second Street
San Francisco, CA 94107
www.chroniclebooks.com

CASH, JOHNNY · 5118 Finger
7·2625, 2658, 2700, 2708 W/
·1964 - Newport 5994 Feets
·1969 " 5469·552 + around
·5118-19-20 Quentin
5121- 26 Oakland w/Robbins
·5303-04·06-07-08 " to 5326
·5687-90 Cash w/ Dylan 5323,24,25,26
·5691-99 - 5823- w/ Silverstein
5819-27 5827-John + June-Best
·5780-96 (OVER)

·600+ ON ·8828 w/ Waylon
6191-95
·8134- 34 Oakland -211.73
·8135- 10 Frames
8806-14- 8797-8800
·8827-50 - More 8831 - John and
& Studio Kid
10,482-91- Oregon- 1983
+ CBS #5 Folsom + Quentin

+ Color.